Dedication

For Oliver Hamilton

Phaidon Press Limited, Littlegate House, St Ebbe's Street, Oxford
Published in the United States of America by E. P. Dutton, New York

First published 1979

© *1979 by Phaidon Press Limited*

ISBN 0 7148 1961 1
Library of Congress Catalog Card Number: 78-24662

Printed in Great Britain by Morrison & Gibb Ltd, Edinburgh.

PISSARRO

'No, like Sisley, I remain in the rear of Impressionism' was how Camille Pissarro assessed his achievement as an artist in a letter to his son Lucien, written in February 1895. The statement is wholly characteristic of the man: slightly self-deprecating, ruthlessly self-critical, yet defiant and challenging. It is, however, more than an expression of self-doubt, for it also prompts a revaluation of Pissarro's role within the Impressionist movement. In this Pissarro is a pivotal figure. He was the only painter to exhibit his work in all eight of the Impressionist exhibitions held between 1874 and 1886, and in his letters many of the theoretical aspects and practical implications of the movement are clearly enunciated.

In many other ways, however, Pissarro is not the archetypal figure of Impressionism in the popular interpretation of that movement. He was born outside France, of Jewish descent. He displayed an interest in artistic movements that eventually transcended the tenets of Impressionism. He passed a great deal of his time out of Paris in the surrounding districts, and his works are governed by a political commitment that ran more strongly in him than in any of the other Impressionist painters. Such features give Pissarro's work a slightly different complexion from that of his associates, and indeed, he assumed an almost rabbinical role in French art in the second half of the nineteenth century. Younger contemporaries spoke of Pissarro in biblical terms, as 'the Good Lord' and 'Moses', descriptions which seem especially appropriate in view of his physical appearance, marked by a long flowing beard which gives the face an authority only belied by the twinkling eyes peering over the top of the spectacles (Plate 48).

Allied to Pissarro's striking outward appearance was his wholly independent outlook on life. He was an assiduous worker for whom art was a quotidian exercise in the disciplining of the mind and the hand. His character is marked by a quiet resignation that can at times almost be equated with a streak of fatalism. Added to this was his loyalty to his family and friends. Above all, however, there was his single-minded approach to art, which won many adherents and made him an important centrifugal force within Impressionism, a movement which is a great deal more diffuse in ideas, aims and personalities than has often been imagined. Fortunately, throughout his life Pissarro evinced a remarkable gift for managing to remain on friendly terms with several particularly difficult personalities, including Degas, Cézanne, and Gauguin. Furthermore, he retained the respect of each of these artists and was frequently consulted by members of the younger generation, including Matisse, who was keen to talk about Impressionism with him. Yet, even though Gauguin, who had an amateur interest in graphology, detected all these characteristics when he analysed a sample of Pissarro's handwriting, he did finally conclude that, regardless of an outward calm, Pissarro harboured a nature that could only be described as 'very complex'. It would be as well to keep this in mind when examining his paintings.

Jacob Camille Pissarro was born on the island of St Thomas in the Antilles in 1830. His father was a shopkeeper in Charlotte Amalie, the capital and principal harbour of St Thomas. The island was at that time a Danish colony, but the Pissarro family remained strongly Francophile. Apart from a short interlude in France at a school near Paris, which he attended between 1842 and 1847, Pissarro spent most of his early life on St Thomas, not abandoning the Antilles until 1855. This isolation from Europe is a fact of great importance for our understanding of Pissarro's development, for he was never exposed to

a long period of formal training as an artist. A chance meeting in 1851/2 with Fritz Melbye, a Danish artist in the employ of the government, at least made Pissarro aware, albeit at one remove, of the strictures of academic art. Melbye's lessons were quickly absorbed during a short visit to Caracas, where they shared a studio. This formative phase induced in Pissarro an acuity of eye, a spontaneity of expression, and an ingenuousness of spirit that was an auspicious start for someone who was later to become entangled with Impressionism. Above all, it encouraged Pissarro to be self-disciplined, and this was a quality that he never lost and that led to a perpetual desire to revise his style of painting. Significantly, on St Thomas and in Venezuela Pissarro interested himself in genre subject-matter and landscape, the very themes that recur later in his paintings in the context of rural France and become a central aspect of his art. There are, unfortunately, very few surviving paintings from this early period and those that do survive are not particularly distinguished. The true quality of Pissarro's rapid development can, in fact, only be seen in his drawings, which are numerous and display a remarkable facility and boldness of execution.

Although Pissarro was undoubtedly exposed to contemporary European art while in the Antilles, it was only indirectly, in the form of prints, popular illustrations and manuals. When he arrived in Paris in 1855, in time for the Universal Exhibition, Pissarro had, for the first time since he was a boy at school, direct access to the works of a host of famous artists. This, therefore, was an important moment in his life, for, like Cézanne, he developed a deep respect for the art of the past. Both artists were innovatory, but, like their Impressionist associates, the changes they introduced into painting were an extension of established principles rather than a complete revision of them. It was a question of knowing which painters to look at, or in which century to search, so that while Manet sought inspiration in Spanish painting, Renoir refreshed himself in the clear light of Italy, and Monet went to north Africa, Pissarro preferred Dutch and French art, mainly of the seventeenth and eighteenth centuries. The birth of Impressionism should perhaps not be regarded as a *tabula rasa*, and its iconoclasm stems from its discontent with the sterile, outmoded and comparatively limited aims of academic art, rather than from stronger motives. 'Novelty lies not in the subject, but in the manner of expressing it', Pissarro wrote in 1884, and this statement implies that much of the apparent spontaneity of Impressionist painting was, in fact, carefully calculated.

At the Universal Exhibition the works of Delacroix and Ingres–the apparent polarities of French nineteenth-century painting–were strongly represented, among other schools, but it was to Corot that Pissarro initially felt drawn, and to the painters associated with the village of Barbizon in the Forest of Fontainebleau. It was, of course, with these painters–Troyon, Diaz, Rousseau, Millet, as well as Corot–that Pissarro felt a close kinship after his experiences in Venezuela, and it was with Corot that he formed his first definite artistic allegiance in France. The early work, *The Banks of the Seine at Bougival* (Plate 1), which was exhibited in the Salon of 1864, displays a suppleness of brushwork, a candour in the treatment of light and a richness of tonality that reveal the direct influence of Corot. To Corot's example, however, Pissarro soon added others, specifically those of Daubigny and Courbet. Where in the paintings that technically owe a great deal to Corot the compositions are tight-knit and strong, those like *The Banks of the Marne at Chennevières* (Plate 3), which was exhibited in the Salon of 1865, have a spaciousness that is found in the work of Daubigny. Other paintings of this early period, such as *A Square at La Roche-Guyon* (Plate 4) or *Still-Life* (Plate 5), which display broader brushwork with layers of thickly applied paint, are derived from the example of Courbet, whose uncompromising style of painting with the palette knife became a basic ingredient of Pissarro's own style. These three principal influences are perfectly blended in the small painting entitled *The Donkey Ride at*

La Roche-Guyon (Plate 2), where the subject and the composition reveal Pissarro's sympathy with Daubigny and Courbet, but the execution his debt to Corot.

Such then were the principal formative influences on Pissarro after his arrival in France when, along with several other painters who were to form the Impressionist group, he sought recognition in the official Salons of the 1860s. From this amalgam Pissarro forged a personal style of painting, which in its first flowering was notable for its strength and individuality of touch, somewhat redolent of Manet in its *bravura* and not dissimilar to Monet's work in its richness. This early style is seen at its best in such paintings as *View of L'Hermitage at Pontoise* (Plate 6), where the paint has been brushed on to the canvas in broad patches of sombre colour in such a way that when certain parts of the composition are viewed in isolation they resemble passages of abstract painting. This deliberate, almost rugged, method of painting was singled out for praise by the few critics, notably Emile Zola, who observed those works exhibited by Pissarro at the Salons, and it was this highly disciplined approach to composition that served as the basis for the important canvases completed during the first half of the following decade. Zola, in fact, wrote a strong defence of Pissarro's two pictures exhibited in the Salon of 1868, *L'Hermitage* and *Jallais Hill, Pontoise* (the latter now in the Metropolitan Museum of Art, New York), which ably summarizes the effect of these early masterpieces. 'The originality is here profoundly human. It is not derived from a certain facility of hand or from a falsification of nature. It stems from the temperament of the painter himself and comprises a feeling for truth resulting from an inner conviction. Never before have paintings appeared to me to possess such an overwhelming dignity. One can almost hear the deep voices of the earth and sense the trees burgeoning. The boldness of the horizons, the disdain of any show, the complete lack of cheap tricks, imbue the whole with an indescribable feeling of epic grandeur. Such reality is more than a daydream. The canvases are all small, yet it is as though one is confronted by a spacious countryside.' Zola concludes, 'Camille Pissarro is one of the three or four true painters of his day. He has solidity and a breadth of touch, he paints freely, following tradition like the old masters. I have rarely encountered a technique that is so sure.'

The decade of 1870–80 began in ferment with the Franco-Prussian war followed by the Commune in Paris. During both of these times of violence Pissarro was in England, together with Monet, Daubigny and Bonvin. Although each of these painters exerted some influence over Pissarro, it was principally Monet who gave direction to his work at this stage. It is wholly characteristic of Pissarro that while Monet painted in the London parks, he chose to remain in the suburbs. Yet in the canvases painted in England and shortly after his return to France there is, as in Monet's work of this period, a lighter, more spontaneous touch and a brighter palette, the colours applied in smaller patches so that the surfaces appear to be crisper and more active. Together with this more vibrant brushwork is the firm geometric structure underlying the compositions that had already been used for the pictures painted at the end of the previous decade. The paintings are governed by lines of vision that lead perpendicularly into the compositions. These are often countered by low horizon lines. The figures and buildings are placed on diagonals drawn at varying angles. These canvases, however, are more than mere exercises in geometry, for, although the compositions can be fairly rigid, Pissarro also involves the viewer in the visual interaction between the various parts, as in the foreground of *The Crossroads, Pontoise* (Plate 9). In such pictures (see also Plates 12, 13 and 14) the artist also explores the full range of dramatic possibilities implicit in roads disappearing over low horizons and paths that follow the contours of hills. To examine these paintings, several of which are small in size, is to discover that they have the same succinctness of expression

combined with the same breadth of interpretation that governs an all-embracing mathematical or philosophical proposition. Furthermore, when individual passages are seen separately as details they do themselves form independent compositions. Many of these canvases of the early part of the 1870s, which include flower-pieces (Plate 10) and family portraits (Plate 11), are amongst the most satisfying that Pissarro painted and they are also in his purest Impressionist manner.

In the middle of the decade Pissarro renewed his acquaintance with Cézanne (Plate 16), whom he had first met in Paris, reputedly at the Académie Suisse, not long after his arrival from St Thomas. Pissarro now established a rapport with Cézanne that was to be of the utmost significance for the development of European painting. The two artists frequently worked together, often painting the same subject, and it is likely that any influence they exerted on one another was on a reciprocal basis. Regardless of their different personalities, their letters reveal a similar commitment to art and a similar purpose in painting, just as drawings and photographs of them show that they dressed in a comparable manner for their forays into the countryside.

As a result of his relationship with Cézanne, which was at its closest between 1872 and 1877, Pissarro's own style of painting changed and became more aggressive. The palette again darkened and became more unified. The brushwork was broader and more forceful, the paint surface itself characterized by an immense solidity that has the appearance of being modelled (Plate 17). Apart from technical considerations, Pissarro and Cézanne also shared an architectonic approach to composition, and Cézanne's description in a letter of 1906 to his son, of some trees in a wooded landscape as forming 'a vault over the water', could easily be applied to a picture such as *The Little Bridge, Pontoise* (Plate 18), which was painted by Pissarro during this very period.

It may, in fact, have been as a result of working with Cézanne that Pissarro began to overload the surface of his pictures. In both *Kitchen Garden with Trees in Flower* (Plate 21) and *The Red Roofs* (Plate 20) the hillside and the buildings are screened by foliage. The effect of this is to draw the eye, as with a kaleidoscope, into the densely patterned background. The eye then attempts to separate the various layers, at the same time glorying in the visual opulence that it finds there. The myriad of short, varied brushstrokes purvey an increasingly wide range of colours, and perhaps only Monet amongst the Impressionists was equal to this detailed and elaborate method of working.

Pissarro, however, was aware of the difficulties of painting in this way. He complained frequently of the fact that his paintings lacked visual clarity and were often dull or muddy in colouring. He became acutely conscious, in fact, that he was over-painting. The density of the surface of these pictures executed at the end of the 1870s and at the beginning of the 1880s was overpowering, and the moment when the form itself suddenly emerged out of the background was harder to achieve. One only has to look at the still-life objects on the table on the right of the composition of *The Little Country Maid* (Plate 27) to see how they have become isolated from the rest of the picture. The laboured treatment of the teacup is an instance of this over-elaboration. It appears to be almost floating on the tablecloth, unconsciously resembling one of Monet's water-lilies. In seeking a solution to this, Pissarro found the theories propounded by Seurat and Signac, involving the division of colour on a scientific basis, to be sympathetic. Like his contemporaries Renoir and Monet, who suffered similar difficulties in their style of painting at this time, Pissarro looked outwards for fresh inspiration. It is also significant that the brushwork used for those paintings executed during the late 1870s and early 1880s, with its neat, short, nervous flicks and commas, anticipated the more regular brushstrokes advocated by the Neo-Impressionists. In addition, the purity of the colour and the brighter palette enabled

Pissarro to rid himself of the muddy effects of his heavily worked canvases. His paintings in the Neo-Impressionist style (Plates 30 and 31), which he adopted between 1885 and 1890, were, therefore, possibly a palliative for the difficulties that he had been experiencing since the late 1870s.

Having recaptured purity of colour and clarity of composition, however, Pissarro found the Neo-Impressionist style increasingly frustrating. The canvases had to be worked on in the studio over long periods. The dot was a painstaking method with which to cover the whole surface of a picture, and it did not allow the artist to record freely those sensations which he had experienced before nature. Pissarro came to resent the technical limitations imposed upon him by Neo-Impressionism, but he nevertheless remained a stalwart admirer of Seurat and was deeply affected by that artist's early death in 1891.

Already in the examples of Cézanne and Seurat we have seen how Pissarro developed his own style of painting by openly embracing a method or technique that was at first sight unrelated to his customary manner of working. Another relationship that is reflected in his art began towards the end of the 1870s and persisted into the 1880s. This was his friendship with Paul Gauguin, to whom his attitude was distinctly equivocal. He seems at first to have admired the break that Gauguin made from the trammels of his family, but later to have despaired of his arrogance and of his persistent use of symbolism. None the less, at the outset, during the late 1870s, Pissarro and Gauguin painted together in areas around Pontoise when Pissarro was himself reconsidering his own style of painting. It was, however, not merely a question of style, and there can be little doubt that for Pissarro the early 1880s were a period of deep inner reflection. Firstly, he discovered several new subjects as a result of travelling more widely. His first protracted visit to Rouen in 1883, for instance, brought him into contact with a city that had a strong topographical tradition amongst French and English artists. In paintings, drawings and prints Pissarro began to capture the appearance of the city – its streets, its majestic cathedral, its busy port – and he was to return to it on several occasions during the 1890s. Apart from the topographical emphasis that the paintings of Rouen demanded, there was also a whole range of atmospheric effects that he determined to translate into paint. As he wrote in a letter of 1896 while painting one of his series of views of the city, 'I have effects of fog and mist, of rain, of the setting sun and of grey weather, motifs of bridges seen from every angle, quays with boats; but what interests me especially is a motif of the iron bridge in the wet, with much traffic, carriages, pedestrians, workers on the quays, boats, mist in the distance, the whole scene fraught with animation and life' (Plate 36).

There is, therefore, a considerable broadening in the range of subject-matter treated by Pissarro, which is best exemplified by the number of market scenes executed during the 1880s (Plates 28 and 29). He had begun to observe markets while in South America, but it was not until he was living in Pontoise and Gisors that he pursued the theme with ardour, depicting the various markets – poultry, grain, egg, vegetable – in densely populated compositions that were to be his equivalent of the urban subjects of Manet, Degas and Renoir. In these market scenes there is a wide spectrum of physical types – both peasant and bourgeois. Even in South America Pissarro's pithy style of drawing had encouraged a caricatural element in his work, and throughout his life he admired artists such as Constantin Guys, Honoré Daumier, and above all Charles Keene. Drawings from this period show Pissarro establishing a basic repertoire of figures, all drawn so quickly that only their principal features or characteristics are recorded, in a summary fashion, on the page. Such strongly delineated sketches appear to be caricatural even if humorous anecdote was not the intention, and the exploitation of humanity's foibles extends beyond the market scenes to include his boulevard pictures (Plate 23), where the figures are admittedly

represented from a distance, but are granted individuality with the aid of a caricatural style.

Secondly, during the 1880s and the early 1890s Pissarro began to reinterpret themes that he had already explored. This development was due to two factors: a new understanding of the human figure and a fresh response to nature. Out of this emerged a new type of composition in which the principal novelty was the relationship of the figure to the landscape. During the 1870s Pissarro tended to place his figures in a subordinate role in relation to the landscape. The figures are seen working in the fields or walking along the roads, but usually in the middle or far distance, and often forming part of a broad panorama which dominates the picture and contains the figure. They are directly related to the landscape, but only in so far as they are perfectly integrated with their surroundings. The figures are often columnar, and even when they do come into contact with the ground, as in the acts of weeding or picking, they tend to bend stiffly from the waist, as though manipulated from above like puppets. Towards the end of the 1870s, however, Pissarro evolved a more sympathetic treatment of the human figure in which his models are not generalized, but closely observed, their dress, and particularly their actions, dexterously recorded. While *Landscape at Chaponval* (Plate 24), for instance, still tends to show the figure isolated and upright, set against the contour of the hillside, *Two Female Peasants Chatting* of 1892 (Plate 32) epitomizes the change of emphasis that Pissarro brought to his treatment of the human figure during the 1880s. Although the lower halves of their bodies are cut, the two young women are far more earthbound than their predecessors of the 1870s. They are defined as individuals by their dress and by their features, and their physical activity, from which they are relaxing, is suggested by the implements they hold and by the background. In paying such close attention to descriptive detail, Pissarro has not failed to relate the figures to the landscape. This integration is exactly the same as that so admirably demonstrated by the paintings dating from the 1870s, but it is achieved in a totally different way. Here the figures are united with the earth. Where before they stood, or bent down to have some contact with the ground, now they sit, recline, crouch, or squat, so that the figure and the earth seem no longer separate entities, but perfectly fused. This development in Pissarro's style is fundamental to our understanding of him as an artist. It implies a more profound appreciation of peasant activities and it was achieved by a closer observation of the peasant at work, or at rest, in the fields surrounding the towns and villages to the north of Paris where Pissarro lived.

This more sympathetic treatment of the human figure in Pissarro's paintings was effected contemporaneously with a change in his rendering of landscape. It has been seen that during the 1870s Pissarro concentrated upon integrating the human figure into the background. During the 1880s and the early 1890s, possibly owing to the growing influence of Degas, there was an increasing tendency to place the figures, whether set in a landscape (Plate 32) or in an interior (Plate 26), in the immediate foreground, posed at angles to the picture plane, often silhouetted against the background and even occasionaly deliberately distorted. They are brought into closer contact with the spectator as they loom out of the canvases, and to a certain extent negate the landscape or interior in which they are painted. The function of landscape therefore changes. Where during the 1870s the possibilities of the firm geometrical structure allowed a great deal of flexibility as the levels of the horizons, the diagonals and the perpendiculars were changed, during the later decades this variety was narrowed down to one or two formulas which were repeated in several different types of composition.

The principal difference between the landscape compositions of the 1870s and those of the 1880s, therefore, lies in the treatment of space. Those painted in the 1870s have a

predilection for spatial recession: roads, rivers, lines of trees disappear into the distance. In the paintings dating from the 1880s the compositions are more enclosed and the horizon lines are often placed above the heads of the figures, so that there is an upward progression of flat horizontal bands. Again the transitional stage is marked by a painting such as *Landscape at Chaponval* of 1880 (Plate 24), where the figure is placed in the foreground and outlined against the field. She is still carefully integrated into the landscape, but there is a tendency to flatten the various parts of the composition. Another transitional painting is *The Harvest* of 1882 (Plate 25), in which the half-length figures in the foreground are set within a landscape bounded by a low horizon line with a shallow hill that is actually painted more than half-way up the canvas. A fine example of the new landscape formula when it was fully developed is provided by *The Apple Pickers* of 1888 (Plate 31), which is painted in the Neo-Impressionist manner. The curved horizon line, the tree placed just to the right of centre, the figures perched rather uncertainly on the ground, which appears almost to tip forward towards the viewer – these are its salient features. Familiarity with a particular landscape, such as the orchard of his house at Eragny or the nearby meadows of Bazincourt, encouraged the ready adoption of such formulas. The variety in the paintings stems solely from the figures, their varied activities and their poses, whilst the landscapes merely provide a suitable stage or backcloth.

Once more in this respect Pissarro's espousal of Neo-Impressionism was an advantage, for it provided him with the means of achieving visual clarity on a densely worked surface. The effect of tipping up the landscape, so that the feeling of recession was negated and the figures were pressed against the background like flowers between the pages of a book, could easily have resulted in a loss of definition. The fact that the figures stand out so sharply from the backgrounds is due to the refinement of technique and colour that Pissarro had attained through the practice of *pointillisme*. In addition, he never totally abandons his sure sense of spatial division, for the geometry of diagonals, horizontals and verticals continues to grant the various parts of the composition an undeniable sense of unity (Plate 31). The brushstrokes retain the short, comma-like form they possessed before 1885, but the adoption of lighter colours in a purer state enables Pissarro to create, by a process of subtle modulation, a sense of distance, and to recapture the palpable atmospheric effects that had been evoked with broader strokes in earlier pictures. The paintings of the last half of the 1880s, therefore, may not be so easy to appreciate as those of the 1870s, but they are the products of a remarkably successful combination of Pissarro's innate skill in organizing space and his newly developed ability in rendering atmosphere with colour.

There is also a marked difference in the treatment of light between the paintings of the 1870s and those of the 1880s and the 1890s. This, too, must have helped Pissarro to achieve a visual unity in his compositions. The picture *Two Female Peasants Chatting* (Plate 32), for example, is bathed in an intense, clear light. It has a luminosity that is not shared by the earlier paintings, in which the sharp light striking buildings, trees and figures is used merely to prescribe their forms. In such works light is used descriptively, whereas in *The Apple Pickers* (Plate 31), or in *Two Female Peasants Chatting*, the intensity of light envelops both the figures and the landscape. This luminosity exists as if to allow us to see the figures properly in their setting.

The paintings of the mid and late 1890s are, on the other hand, similar in many respects to those of the 1870s, although the technique is a natural development from the Neo-Impressionist phase. Many of the canvases are heavily worked, but the visual content is immediately comprehensible and solidly constructed in the manner of the 1870s. The compositions of interiors are still contrived, partly as a result of using posed models

(Plates 34 and 35). In the landscapes the paint is thickly applied and layered onto the canvas so that it almost embosses the surface with supple, full-bodied brushstrokes (Plate 43). These paintings mark the return from *pointillisme* and are almost a celebration of Pissarro's rediscovery of the textural qualities of paint. The motifs of the fields surrounding Eragny and the peasants who work in them become far less frequent. Even the beloved orchard at Eragny occurs only occasionally (Plates 42 and 43). Instead, Pissarro explored subjects that he had never painted before with such persistence. He was partly driven to this by necessity after contracting an eye disease diagnosed as an infection of the tear duct, which caused him to remain indoors. As a result he painted views that he could observe from behind the protection of a window in a house or an hotel. An increasing interest in urban themes is demonstrated by the series of boulevards, bridges, harbours, buildings and gardens, painted predominantly in France (Paris, Rouen, Dieppe and Le Havre), but also in England, which Pissarro visited several times during the 1890s to see his son Lucien. Significantly, Pissarro remains above street level (Plates 34–41). He does not go down into the streets; the people who pass along them do not really interest him, and they are briefly drawn onto the canvas without being closely defined. These paintings have an urban claustrophobia, which is an important clue to our understanding of Pissarro, whose deliberate evocation of the countryside has to be balanced with this late return to a traditional subject of Impressionist painting.

As in the 1870s, Pissarro now explored temporal effects. His urban views show the gardens (Plate 39), the boulevards (Plate 37) and the buildings (Plates 46 and 47) of French cities in the morning light, in the rain, in the mist, and each at a different time of day or year. Beyond this habit of relentless work there is a rekindling of the desire to paint in series, so that Pissarro's career, like Monet's, ends almost symphonically; both artists bring all their experience to bear on the depiction of those effects that are the quintessence of Impressionism – time and light. These canvases demand the viewer's close attention. Their subtlety lies not just in the colour, which is less intense now and rather suffused with a silvery tone, but also in the dexterity of the physical application of paint, no doubt the result of a protracted working process as the artist's powers of concentration failed. On short acquaintance these paintings might appear to be too uniform, but, like Monet's more renowned series of haystacks and water-lilies, the late paintings of Pissarro draw you into a closed world of miraculous colour contrasts and multifarious brushstrokes.

These urban themes, however, were not the only subjects that Pissarro essayed during the 1890s. A new departure is marked by the painting *Peasant Girl Bathing her Legs* (Plate 33). Scenes of such intimacy are rare in Pissarro's work, but in several paintings executed during this final decade, and even more in his prints, the artist suddenly undertakes a study of female bathers in sylvan settings, somewhat in the manner of Cézanne and Renoir. Pissarro frequently complained that he was inhibited by the lack of female models, but this did not prevent him from attempting several Arcadian compositions which may be directly compared with an earlier French tradition, namely that of Boucher and Fragonard.

This is not the least surprising aspect of the final decade. Particularly moving is the realization that Pissarro's fascination with the ports of Dieppe and Le Havre echoes the scenes first witnessed as a youth at Charlotte Amalie, the capital of the island of St Thomas. Thus, Pissarro's life seems to have progressed in a cyclical way, creating a surprising unity out of a vast œuvre of paintings, drawings and prints. By the 1890s these two French ports were also fashionable seaside resorts, but Pissarro eschewed the attractions of the social life pursued there and, as at Rouen, he preferred to observe the activities of quaysides and harbours. People, as elsewhere in these late works, are of no

great consequence, but instead the rain, the wind, the smoke, and the movements of the various types of shipping hold him in thrall (Plates 44 and 45). When it is recalled that in the nineteenth century the approach of death is often symbolized by marine imagery, Pissarro's preoccupation with the shipping at Dieppe and Le Havre cannot be misconstrued.

This short examination of the style of Pissarro's paintings has revealed that fundamentally he retained the same principles throughout his working life. Underlying all his compositions is a predetermined framework. The figures and the backgrounds bear a closely defined relationship one to the other, and the precision with which their positions are plotted on the canvas, even when there is an attempt to conceal this from the viewer, demonstrates with what care Pissarro planned every composition. The essential differences in the treatment of space noted between the canvases of the 1870s and those of the 1880s really amount to different solutions to the same problem. In this matter it is hard to divorce Pissarro's personality from his artistic output, for his paintings do seem to be a perfect expression of his character as we know it from his own letters or from the writings and utterances of contemporaries. The very deliberate way in which Pissarro devised his compositions emphasizes his single-minded approach to life. Indeed, the artist's ability to translate nature as he saw it before him onto his canvas suggests more than the astonishing eye for shape and form that had impressed Cézanne, and indicates, as Zola realized at the outset, something more deep-seated than skill. One is therefore bound to ask whether Pissarro had a particular philosophy of life and what relationship, if any, it bore to Impressionism.

It is true to say that Pissarro, as he himself was fully aware, stood slightly apart from his contemporaries in the Impressionist movement. 'I have in me something which chills the enthusiasm of people – they become frightened', he wrote to his son in 1891. While no single painting by Pissarro can be described as overtly political, he was, none the less, a man with strong political convictions, and these are often reflected in the subject-matter of his paintings. The *Portrait of Cézanne*, which was painted in 1874 and was still kept in the painter's studio at the end of his life, provides us with some insight into these political views (Plate 16). The figure of Cézanne is seen in three-quarters profile, looking out of the picture to the right. He is dressed in outdoor clothes and wears a cap. Presiding over him, and therefore by implication over Pissarro, are two political cartoons from French newspapers. On the left, a cartoon by André Gill from *L'Eclipse* of 4 August 1872, entitled 'La Délivrance', shows Adolphe Thiers holding a new-born baby which represents the indemnity paid to the Germans after the Franco-Prussian war, while France, personified by the woman reclining on the bed, looks on. In the upper right corner of the portrait there is a cartoon by Léonce Petit from *Le Hanneton* of 13 June 1867, which shows the painter Gustave Courbet, with a palette in his hand and a clay pipe in his mouth. These are the polarities of Pissarro's political world: on one side Thiers, the entrenched conservative, the crusher of the Commune, and on the other, Courbet, whose paintings and manifestos deliberately taunted the bourgeoisie. Pissarro had been born into a bourgeois family. He later described his visit to Venezuela in 1852–4 to the young painter Armand Guillaumin as follows: 'I was at St Thomas in 1852 in a well-paid job, but I could not stick it. Without more ado I cut the whole thing and bolted to Caracas in order to get clear of the bondage of bourgeois life.' This statement should not be taken as a true expression of Pissarro's political views at that early date, but it is certainly apparent that his opinions hardened after arriving in France in 1855, so that by 1882 Renoir was protesting, 'The public does not like anything that smacks of politics and I do not wish at my age to be revolutionary. To remain with Pissarro the Jew is to be tainted with

revolution.' Pissarro expressed sympathy with the anarchist movement in France, but he was not an activist and is far removed from the traditional image of anarchists derived from the novels of Joseph Conrad or Fyodor Dostoevsky. In fact, as regards the main political events that took place in France during his lifetime, Pissarro is conspicuous by his absence, and the report prepared on him by the police shows that they were not deeply concerned about his political sympathies. How then were these views expressed in Pissarro's paintings?

Pissarro is often compared with his illustrious predecessor Jean-François Millet, but there is in fact a clear distinction between their work, and an entirely different purpose in their treatment of peasant life. Pontoise, for instance, where Pissarro lived from 1866 to 1868 and 1872 to 1883, was to the north of Paris in an area that was rapidly changing its character. There factories were being built as a result of industrial expansion. Factory buildings were beginning to dominate the landscape, just as they were forcing changes on the character of the population. The pattern of rural life was becoming fragmented as those families who had previously worked on the land were being sucked into large conurbations. Pissarro's paintings of factories (Plate 15), which were executed during the mid 1870s, do therefore accurately record an economic development in French society, but it was not one with which the artist appears to have been wholly in sympathy. The fact that urban growth was having such a dramatic effect on nineteenth-century life in France meant that Pissarro's view of the peasant was very different from Millet's. Indeed, this is reflected in the changing attitude to Millet's own paintings, which during Pissarro's lifetime had come to be equated with romantic evocations of the countryside overlaid with religious feelings. Millet's peasants fill the canvas with Michelangelesque proportions. They are bounded by strong contours; they have a fatalistic air; they are depicted as slaves in a base and corrupt world, seeking ennoblement in the court of humanity. Their plight, however, is changeless. It is a static world from which there is no means of escape. As Degas once remarked, Millet's paintings are for God, Pissarro's are for man.

Pissarro is not concerned to show the peasant way of life in such a pessimistic light. Indeed, he saw that very way of life as an important corrective to the suffering induced by the growth of urbanization so vividly depicted in his album of drawings entitled *Turpitudes Sociales* (1890). For inherent within rural society was the only remaining acceptable form of social justice. Thus Pissarro hoped to re-establish the structure, rhythm and pattern of rural life, not in its outmoded, sentimental, medieval form, but in a modern context. The countryside for Pissarro was not simply a retreat from urban life, a place for refreshing the spirit, but the only viable alternative to the social ills poisoning life in the towns and the cities. As such, the *mores* of peasant life provided an important blueprint for the future and were seen as the only means of obtaining salvation in this world. Such sentiments represent a shift from the world of martyrology to that of the pedagogue, and with Pissarro the theme of the peasant in art does indeed change from a myth into a confirmed political philosophy. One observes that Pissarro's paintings of peasants, executed during the 1880s when he first began to develop these ideas in full, are bathed in a clear, sharp light of almost visionary quality, which to a certain extent emphasizes the idealistic nature of his art (Plate 25). For Pissarro's attitude to the peasant is an admixture of the eighteenth-century Enlightenment and nineteenth-century Utopianism, reinforced by a reading of contemporary anarchist tracts published by such friends as Jean Grave, as well as by his own observations made in the outlying country districts where he chose to live. The thinkers who influenced him most were Proudhon, Kropotkin and Reclus, whose

works he knew well and whose ideas fuelled his own passionate concern for humanitarian principles.

When Pissarro first exhibited his work in the official Salons, critics naturally concentrated their faculties on his style of painting, but later critics of a younger generation recognized, even more clearly than Zola, the relationship between the style of the artist and the philosophy of the man. Such writers were Félix Fénéon, Gustave Geffroy, Georges Lecomte and Octave Mirbeau, all of whom were friends of the artist. Geffroy wrote at the time of an exhibition of Pissarro's work held at the gallery of Durand-Ruel in 1894, 'The philosopher and the poet are inseparable within his work and the result is not only a practical demonstration, but also an illuminating résumé of the nature of things and of passing phenomena magnificently and definitely captured.' Mirbeau, in his moving preface to the catalogue of the posthumous exhibition of 1904, wrote, 'The eye of the artist, like the mind of a philosopher, reveals the larger aspects of things, the totalities, the harmony.' In recent times it has been the failure to realize this connection between the art and the thought of Camille Pissarro that has dogged the study of his work and, indeed, that of his fellow Impressionists as well. 'Remember', he wrote to his son in November 1883, 'that I have the temperament of a peasant *(rustique)*, I am melancholy, harsh and savage in my works, it is only in the long run that I can expect to please, and then only those who have a grain of indulgence; but the eye of the passer-by is too hasty and sees only the surface. Whoever is in a hurry will not stop for me.' Pissarro's lack of success not only resulted in periods of financial hardship, but also caused him to question the validity of his own work and ideas. On such occasions he turned to his son for reassurance, and it was Lucien who replied to his father in 1894, 'You are surprised that the public does not look at your paintings and you explain this by supposing that they lack something essential. But do you not realize that it is only a question of fashion? You are too reserved *(tranquille)*, you have ideas that are too expansive *(large)*, and you are too sensible *(bon)* to be fashionable. Indeed, you have yet to be discovered.'

Outline Biography

1830	Born on 10 July, on the island of St Thomas, West Indies.
1842–7	School at Passy in France.
1847–52	Returns to St Thomas.
1852–4	Visit to Venezuela with Fritz Melbye.
1855	Returns briefly to St Thomas, and towards the end of the year leaves the West Indies for Paris.
1856–8	Paints and studies in Paris.
1859	A landscape accepted by the Salon jury; exhibits several pictures at the Salons of 1864, 1865, 1866, 1868, 1869 and 1870.
1860–5	Works in the countryside surrounding Paris.
1861	Meets Monet and Cézanne at the Académie Suisse.
1863	Participates in the Salon des Refusés. Birth of his eldest son, Lucien.
1866	Settles in Pontoise.
1869	Moves to Louveciennes.
1870–1	Franco-Prussian war and the Commune in Paris; flees to Britanny and then to London, where he marries Julie Vellay, who was to bear him a further six children. Meets Durand-Ruel, the Parisian dealer who bought and exhibited the work of the Impressionists.
1871	Returns to Louveciennes.
1872	Settles again in Pontoise, and also paints in nearby Osny and Auvers-sur-Oise, often in the company of Cézanne and Guillaumin.
1874	Contributes to the first Impressionist exhibition and subsequently to the other seven Impressionist group exhibitions, 1876, 1877, 1879, 1880, 1881, 1882 and 1886.
1874–7	Frequently works in Britanny at Foucault, near Mayenne, at a farm owned by an artist friend Ludovic Piette, who dies in 1877.
1878	Establishes a studio in the Rue des Trois-Frères, Paris.
1883	Lucien Pissarro leaves for England and his departure marks the beginning of an extended correspondence. Important visit to Rouen, where he returns several times during the 1890s.
1884	Moves, and finally settles in Eragny after a short period at Osny. In 1892 Madame Pissarro buys the house, with its orchard which, together with the surrounding areas, has been the subject of several paintings since 1884. The artist's studio was situated in the orchard and is still standing.
1885	Meets Signac and is introduced to Seurat, with whom he discusses the technique of painting.
1885–91	Adopts the Neo-Impressionist manner for his paintings and exhibits with avant-garde groups in Brussels and Paris.
1890	Visits London to see his son Lucien; also in 1892 and 1897.
1894	Outbreaks of anarchist violence in Paris. Flees to Knokke-sur-Mer in Belgium.
1893–1903	Paints several series of urban themes based on the cities of Rouen, Paris, Dieppe and Le Havre, usually viewed from hotel rooms.
1903	Dies on 13 November in Paris.

Select Bibliography

J. Rewald, *The History of Impressionism*, 4th edn., London and New York, 1973.

J. Rewald, *Camille Pissarro*, London, 1963.

Camille Pissarro: Lettres à son fils Lucien, ed. J. Rewald with the assistance of Lucien Pissarro, French edn., Paris, 1950. This is the most serviceable edition. English translations date from 1943 (New York) and 1972 (New York).

L. R. Pissarro and L. Venturi, *Camille Pissarro: Son Art et son Œuvre*, 2 vols., Paris, 1939.

K. Adler, *Camille Pissarro: a biography*, London, 1978.

List of Plates

41. *The Church of St Jacques, Dieppe.* 1901. Canvas, 54.5 × 65.5 cm. Paris, Louvre (Jeu de Paume).

42. *Harvest at Eragny.* 1901. Canvas, 51.5 × 64.7 cm. Ottawa, National Gallery of Canada.

43. *Sunset at Eragny, Autumn.* 1902. Canvas, 73 × 92 cm. Oxford, Ashmolean Museum (Pissarro Gift).

44. *Dieppe, Bassin Duquesne, Low Tide, Sun, Morning.* 1902. Canvas, 54.5 × 65 cm. Paris, Louvre (Jeu de Paume).

45. *The Pilot's Jetty, Le Havre, Morning, Grey Weather, Misty.* 1903. Canvas, 65 × 81.3 cm. London, Tate Gallery (Pissarro Gift).

46. *Pont Royal and the Pavillon de Flore, Paris.* 1903. Canvas, 54 × 65 cm. Paris, Musée du Petit Palais.

47. *The Seine and the Louvre, Paris.* 1903. Canvas, 46 × 55 cm. Paris, Louvre (Jeu de Paume).

48. *Self-Portrait.* 1903. Canvas, 41 × 33.3 cm. London, Tate Gallery (Pissarro Gift).

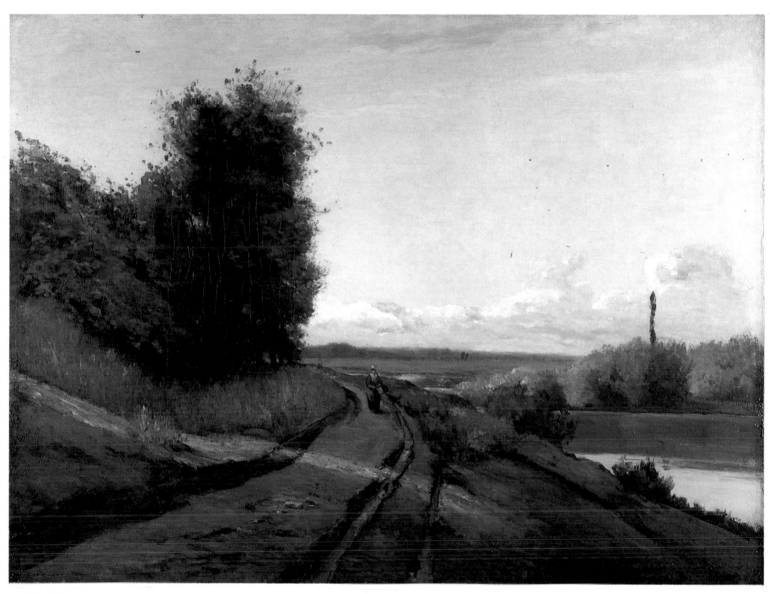

1. *The Banks of the Seine at Bougival.* 1864.
Glasgow, City Art Gallery

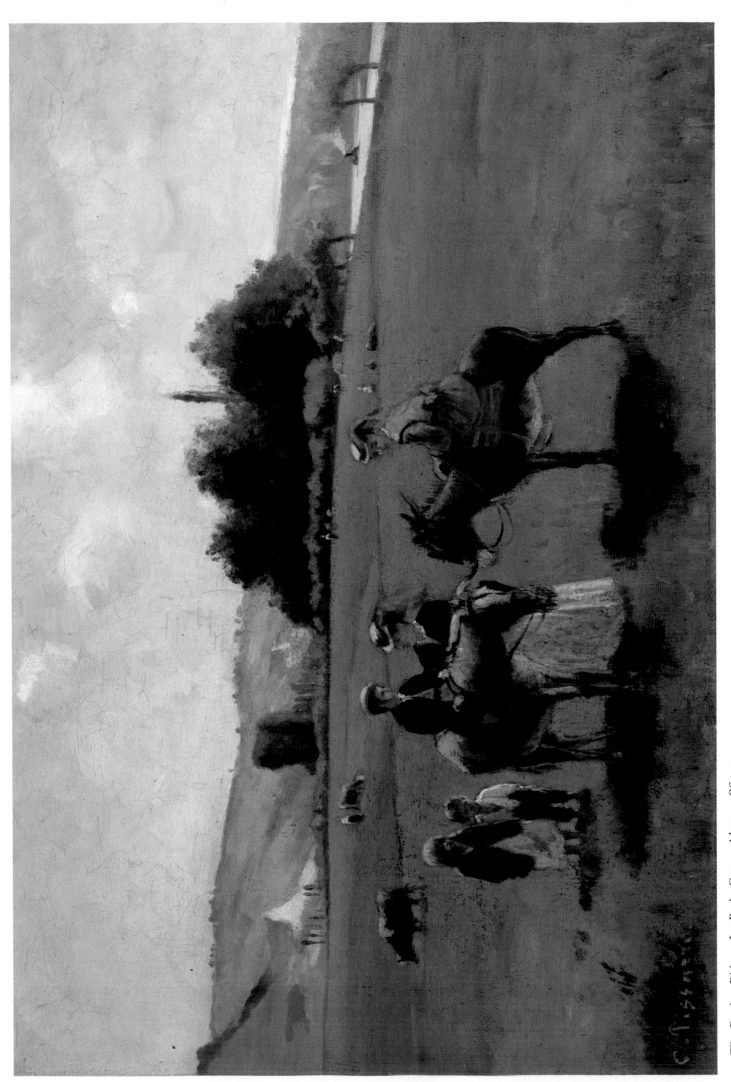

2. *The Donkey Ride at La Roche-Guyon.* About 1864–5.
Formerly Basle, Robert von Hirsch Collection

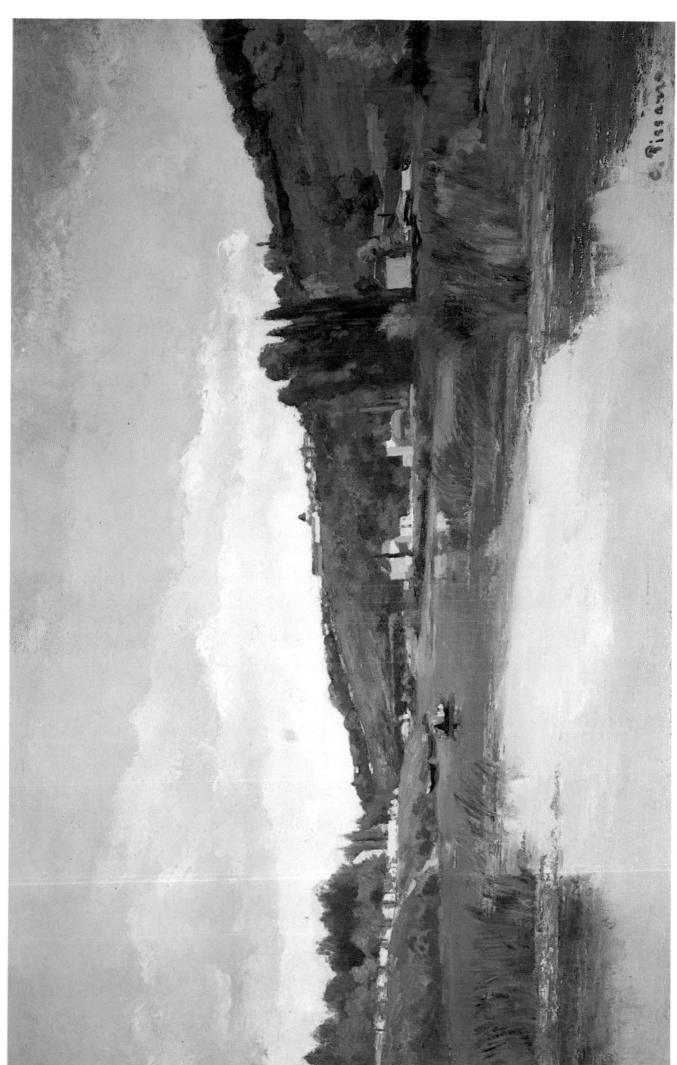

3. *The Banks of the Marne at Chennevières*. About 1864–5.
Edinburgh, National Gallery of Scotland

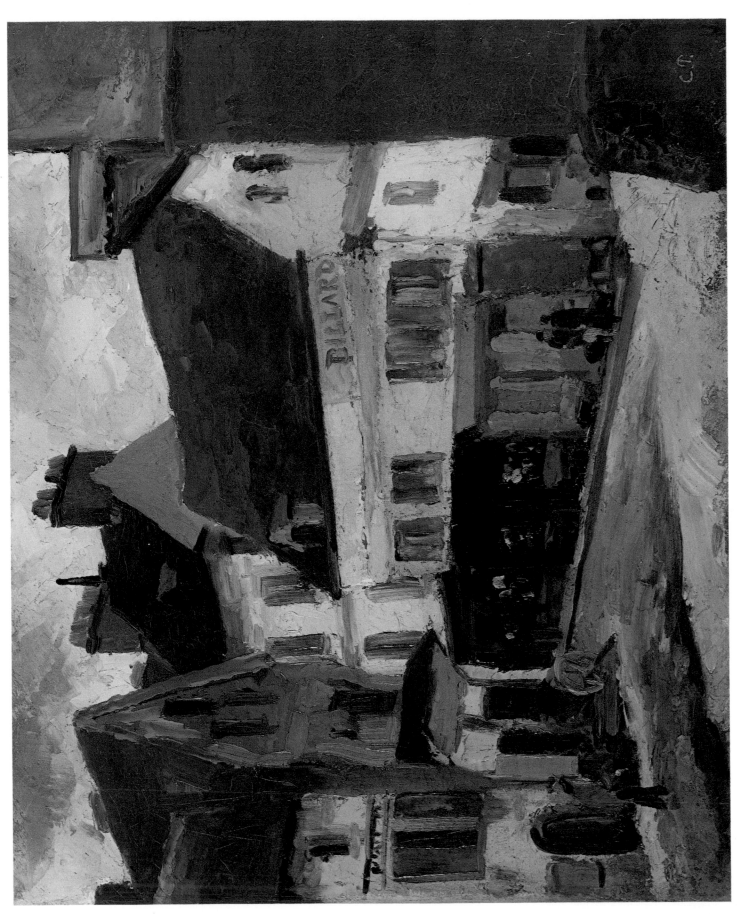

4. *A Square at La Roche-Guyon.* About 1867.
Berlin-Dahlem, Nationalgalerie

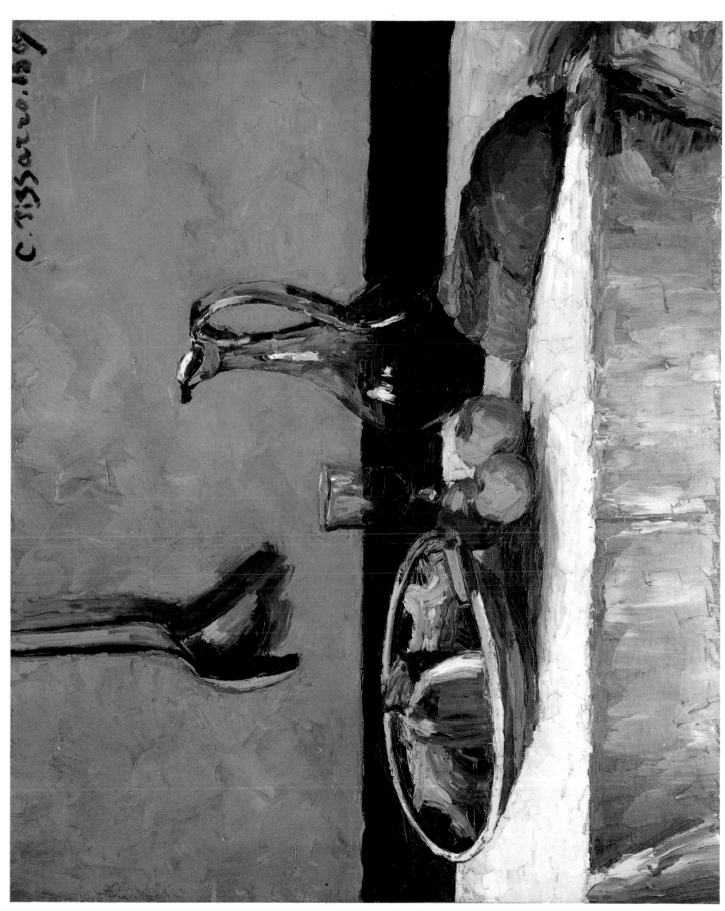

5. *Still-Life.* 1867.
Toledo, Ohio, Museum of Art

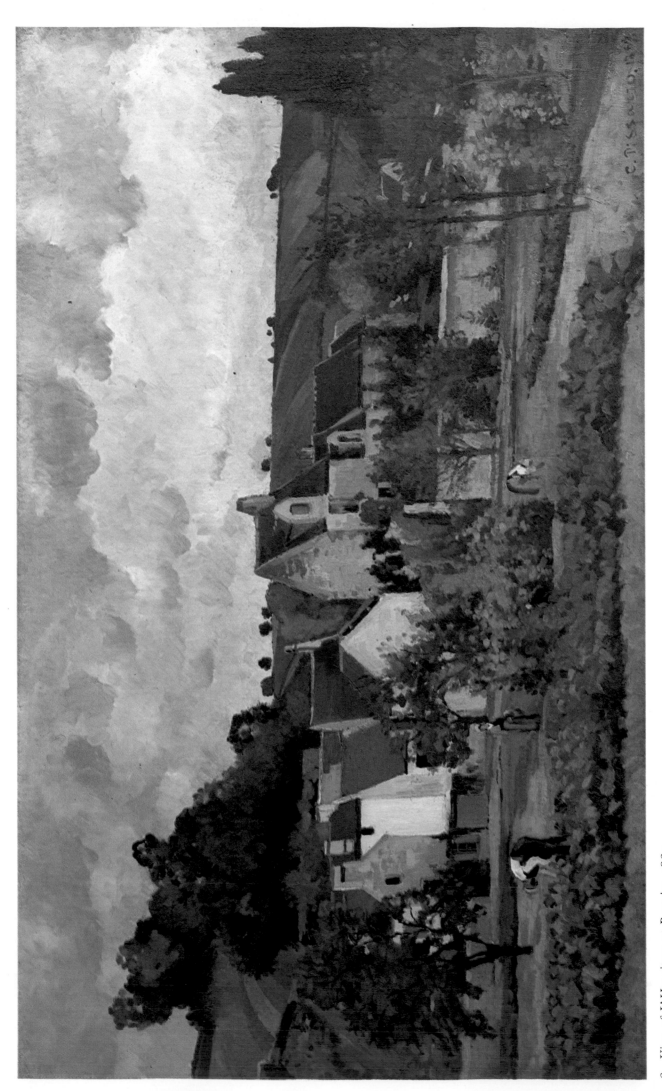

6. *View of L'Hermitage at Pontoise.* 1867.
Cologne, Wallraf-Richartz Museum

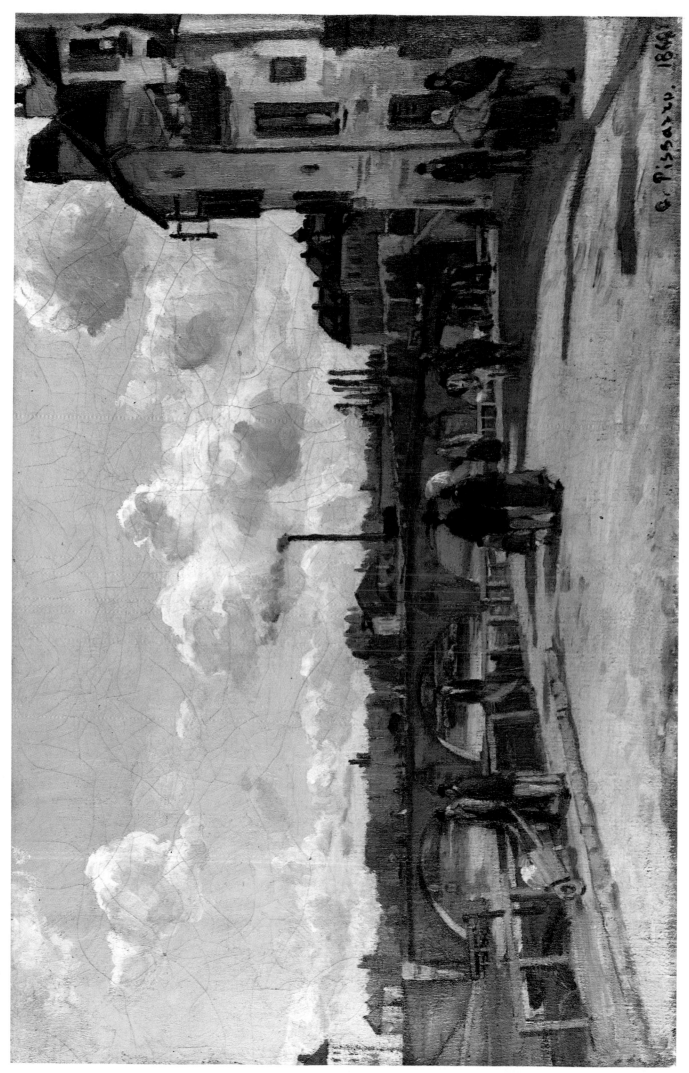

7. *View of Pontoise: Quai au Pothuis.* 1868.
Mannheim, Städtische Kunsthalle

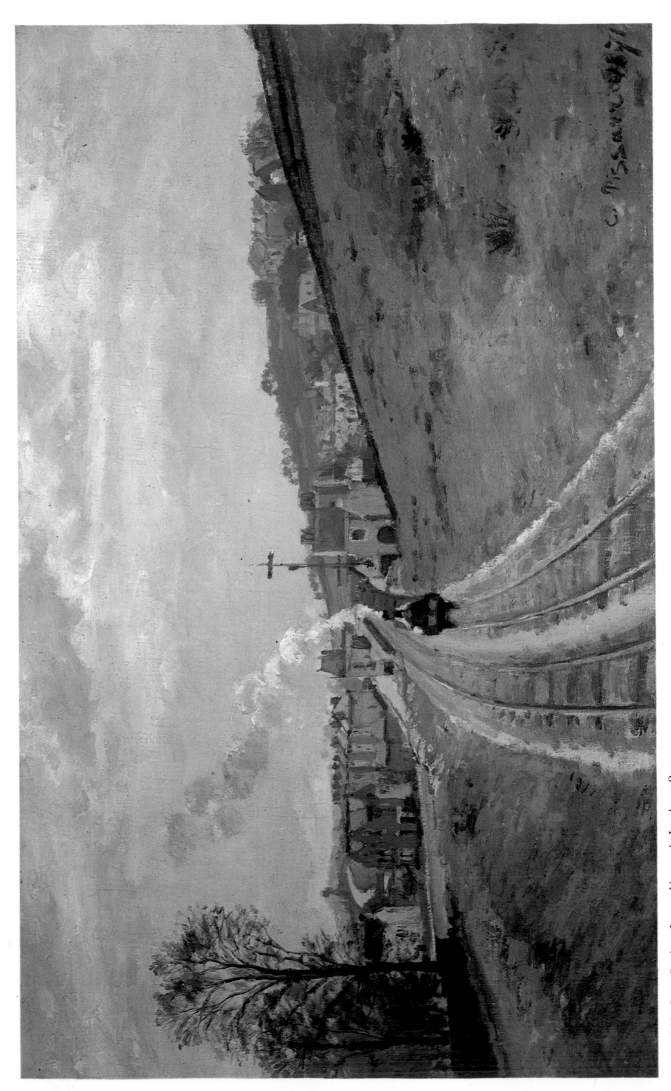

8. *Lordship Lane Station, Lower Norwood, London.* 1871.
London, Courtauld Institute Galleries

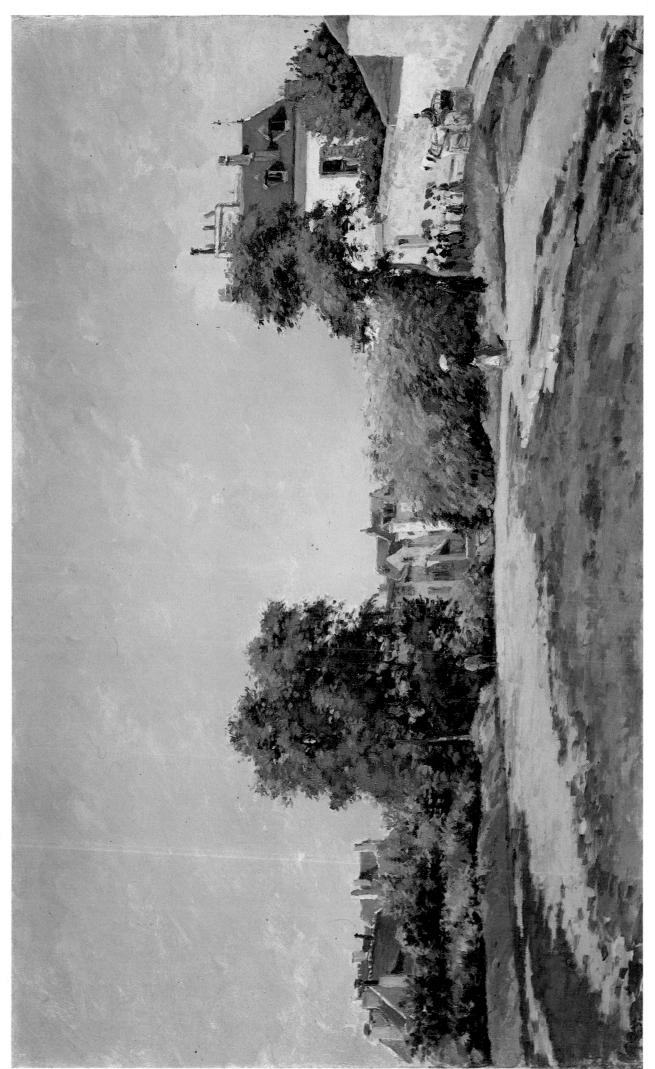

9. *The Crossroads, Pontoise.* 1872.
Pittsburgh, Museum of Art, Carnegie Institute

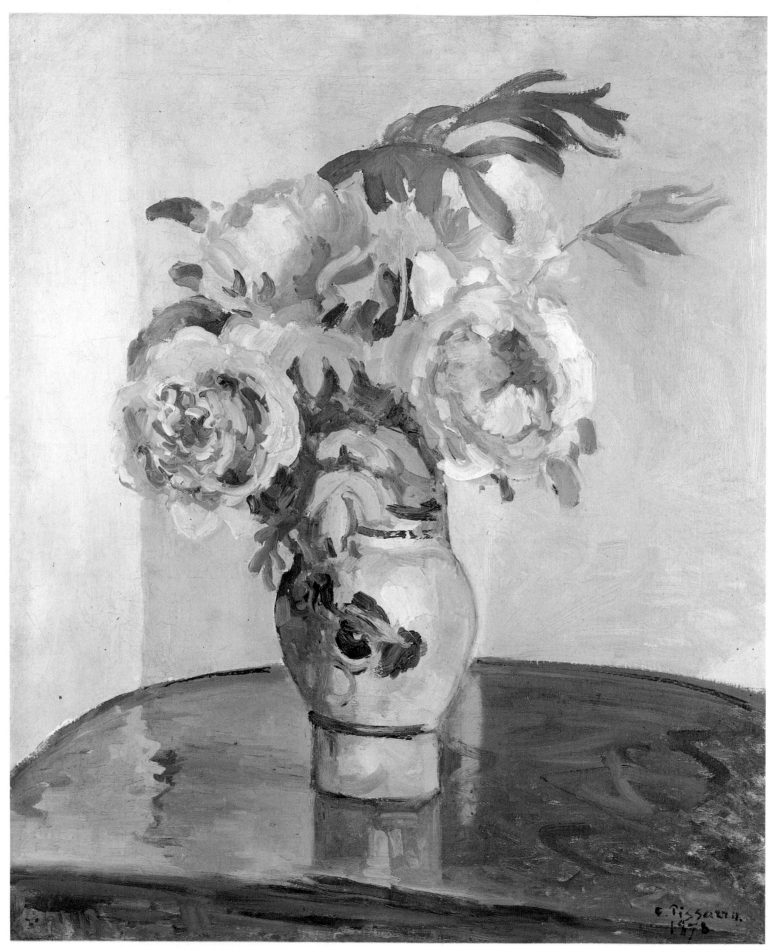

10. *Pink Peonies*. 1873.
Oxford, Ashmolean Museum (Pissarro Gift)

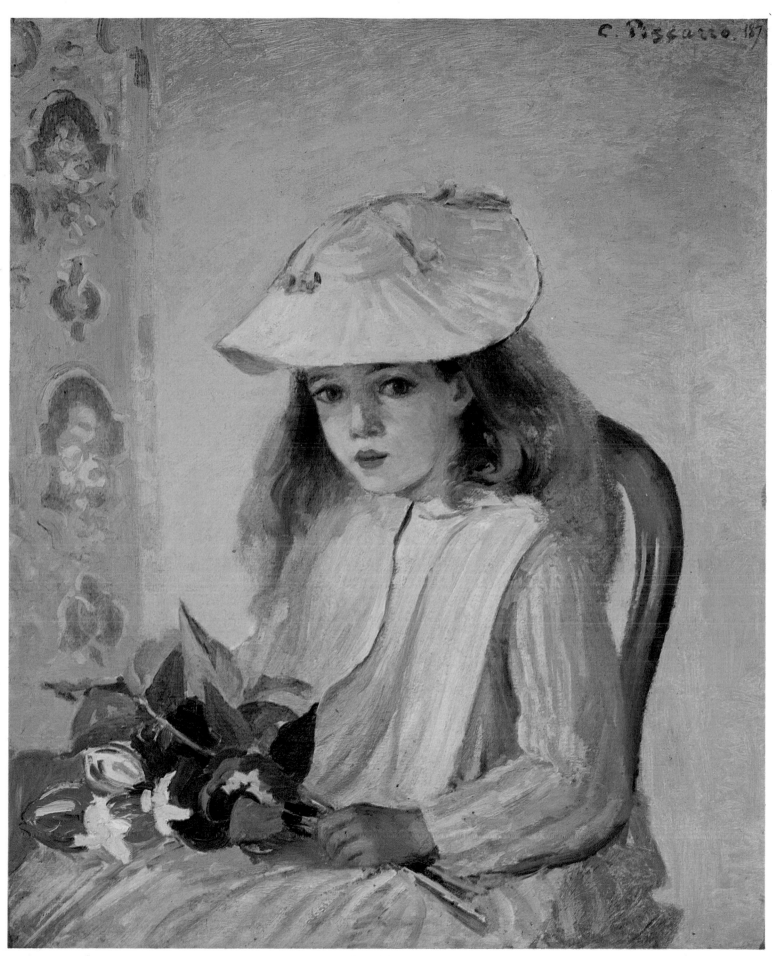

11. *Portrait of Jeanne.* 1872.
New York, John Hay Whitney Foundation

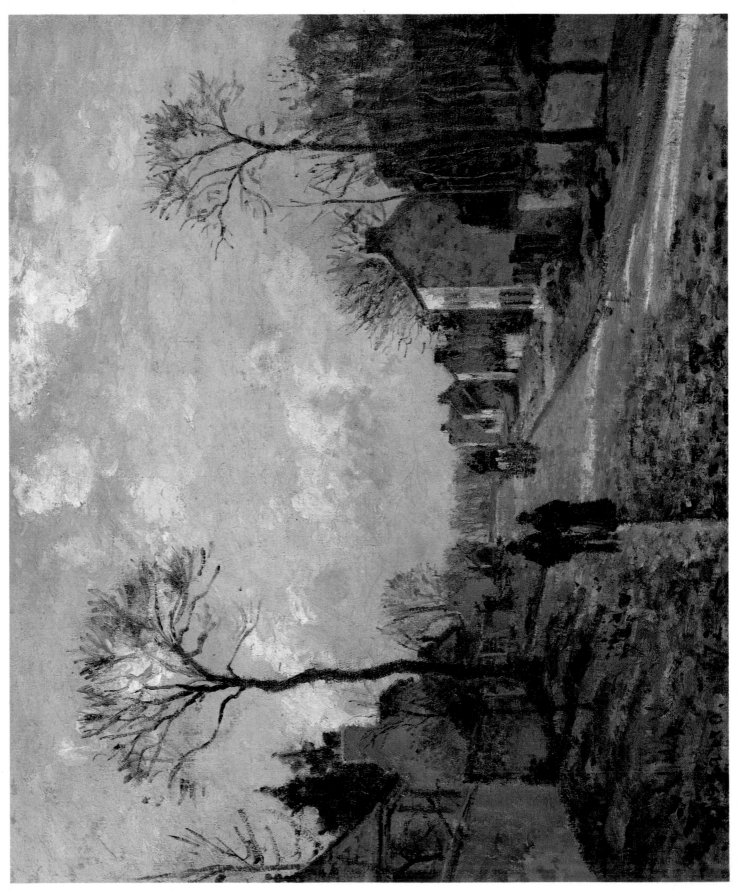

12. *A Road in Louveciennes.* 1872.
Paris, Louvre (Jeu de Paume)

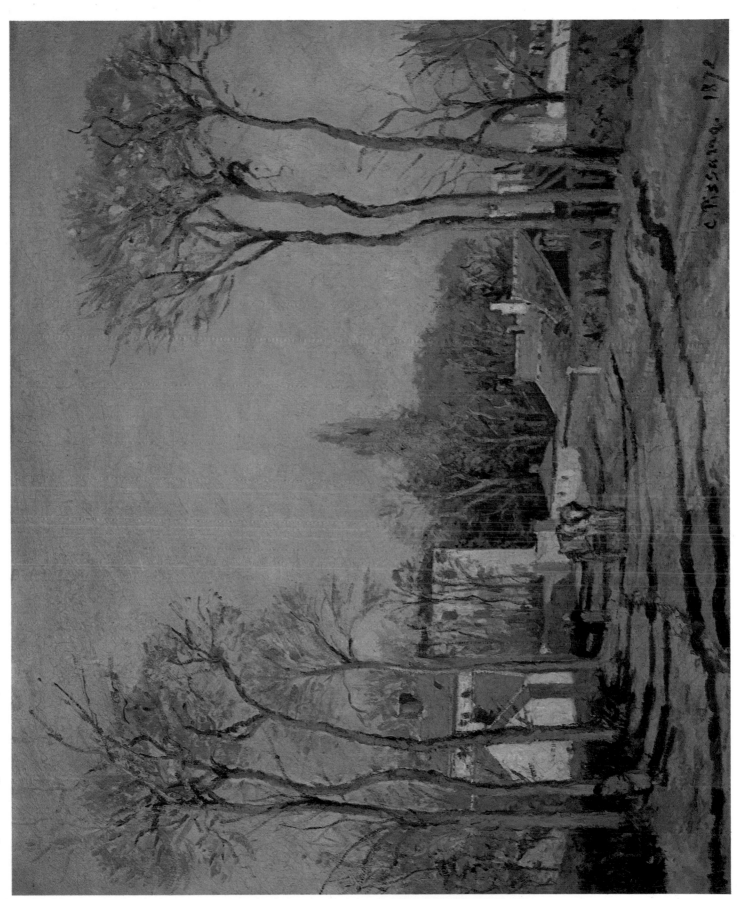

13. *The Entrance to the Village of Voisins.* 1872.
Paris, Louvre (Jeu de Paume)

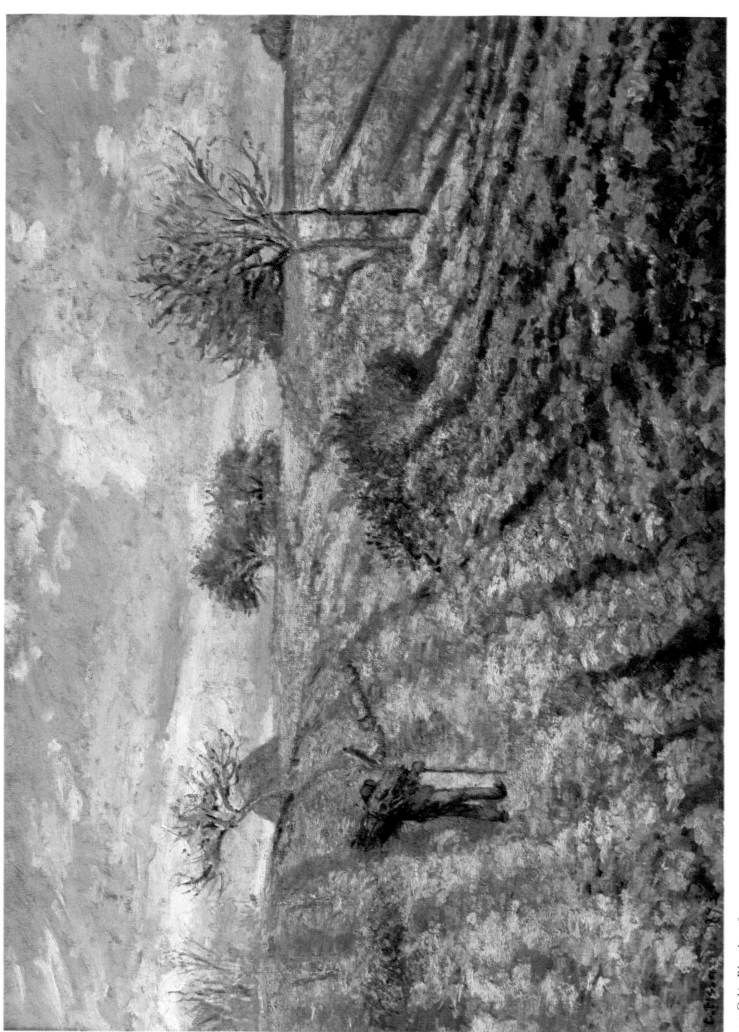

14. *Gelée Blanche.* 1873.
Paris, Louvre (Jeu de Paume)

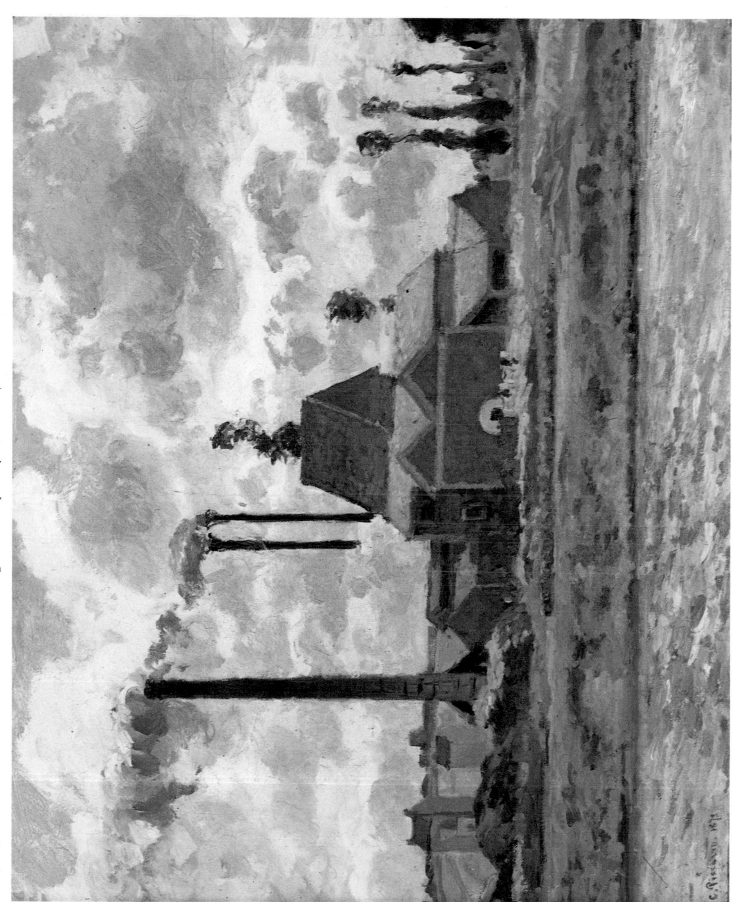

15. *Factory at Pontoise*. 1873.
Springfield, Massachusetts, Museum of Fine Arts (James Philip Gray Collection)

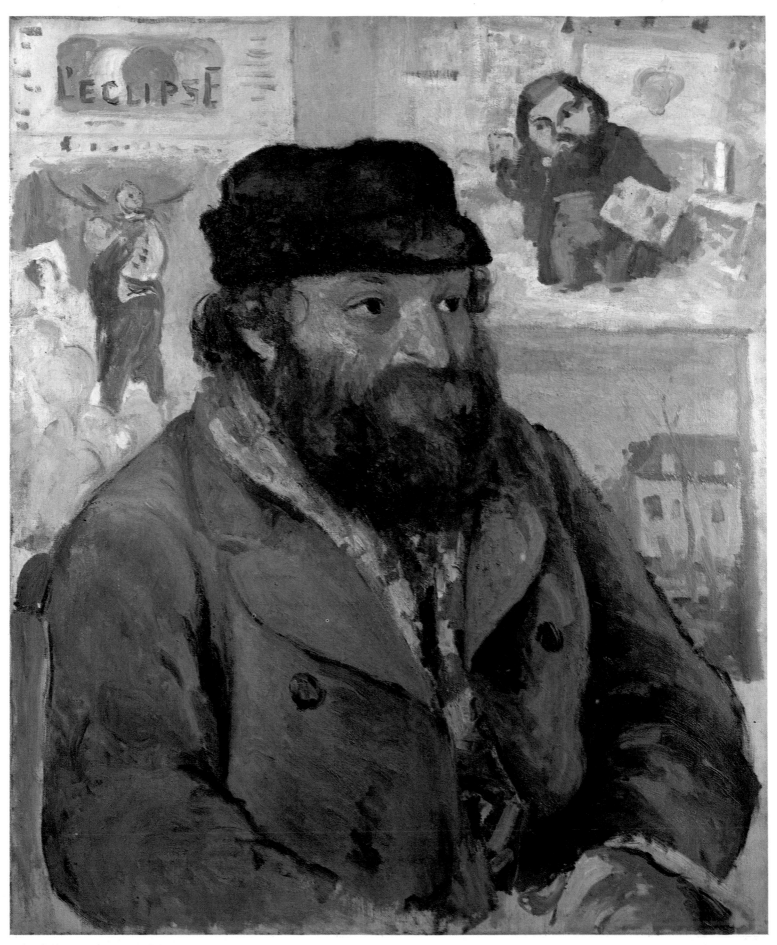

16. *Portrait of Cézanne.* 1874.
Formerly Basle, Robert von Hirsch Collection

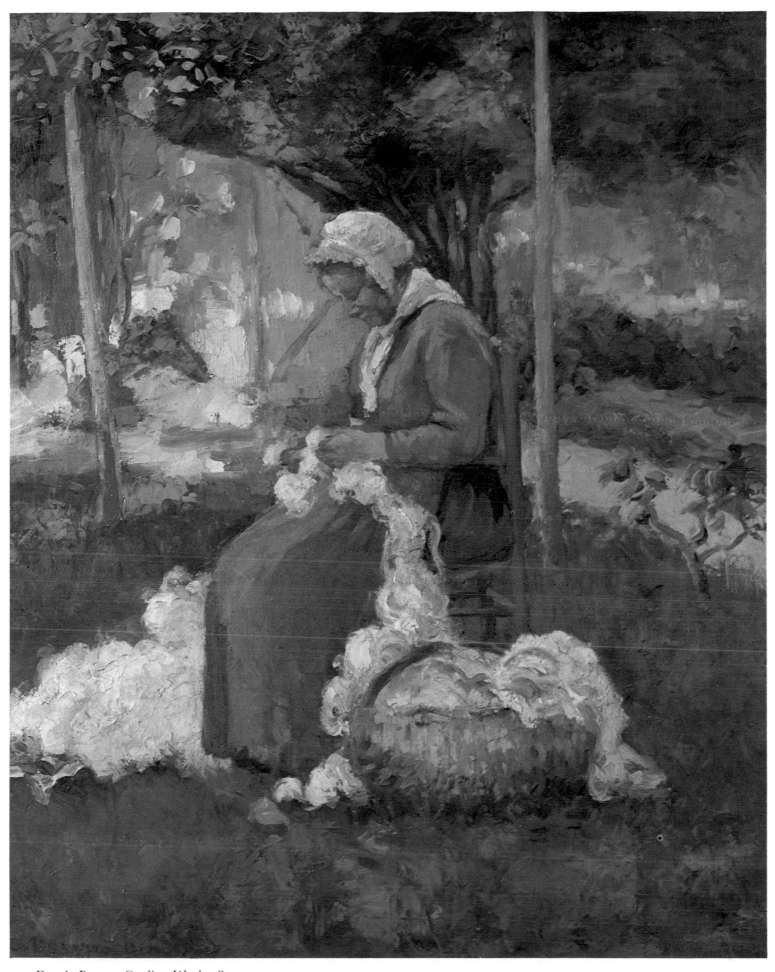

17. *Female Peasant Carding Wool.* 1875.
Zurich, Emil G. Bührle Foundation

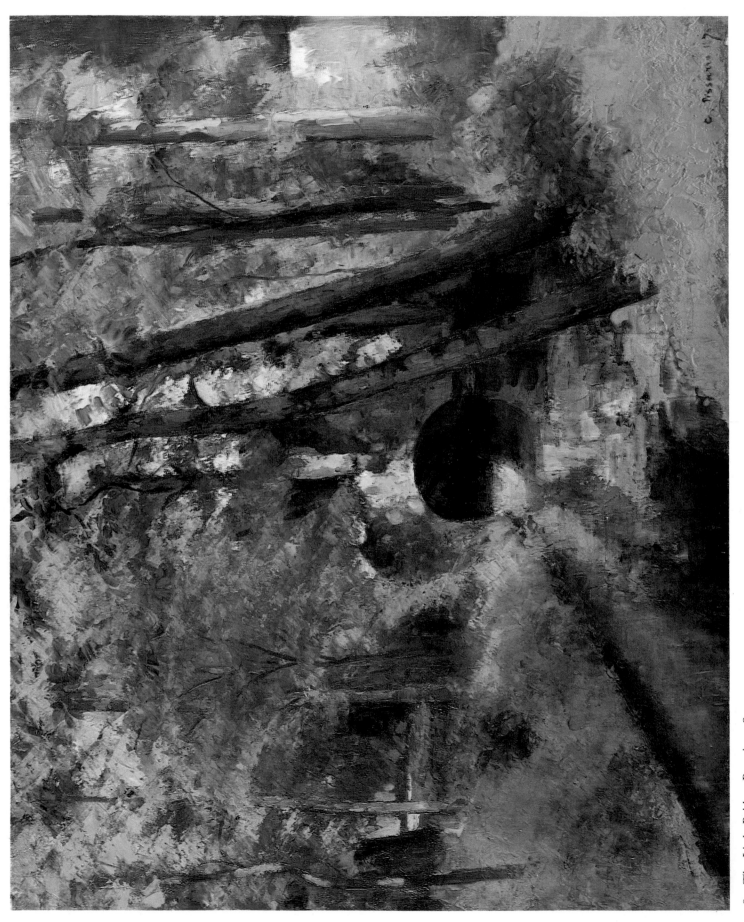

18. *The Little Bridge, Pontoise*. 1875.
Mannheim, Städtische Kunsthalle

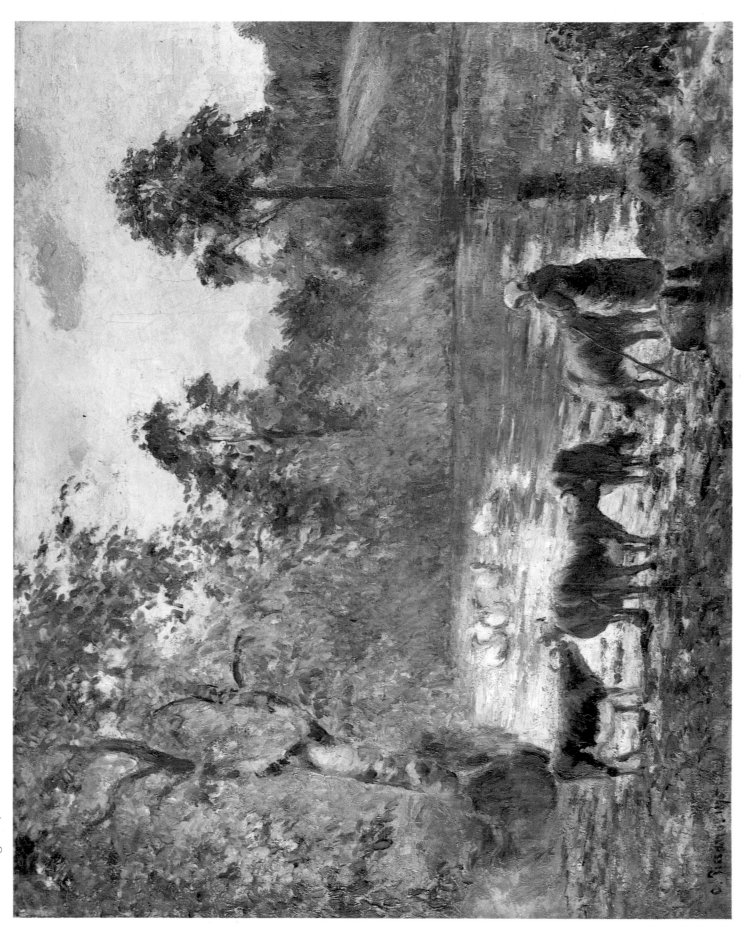

19. *The Pond at Montfoucault.* 1875.
Birmingham, Barber Institute of Fine Arts

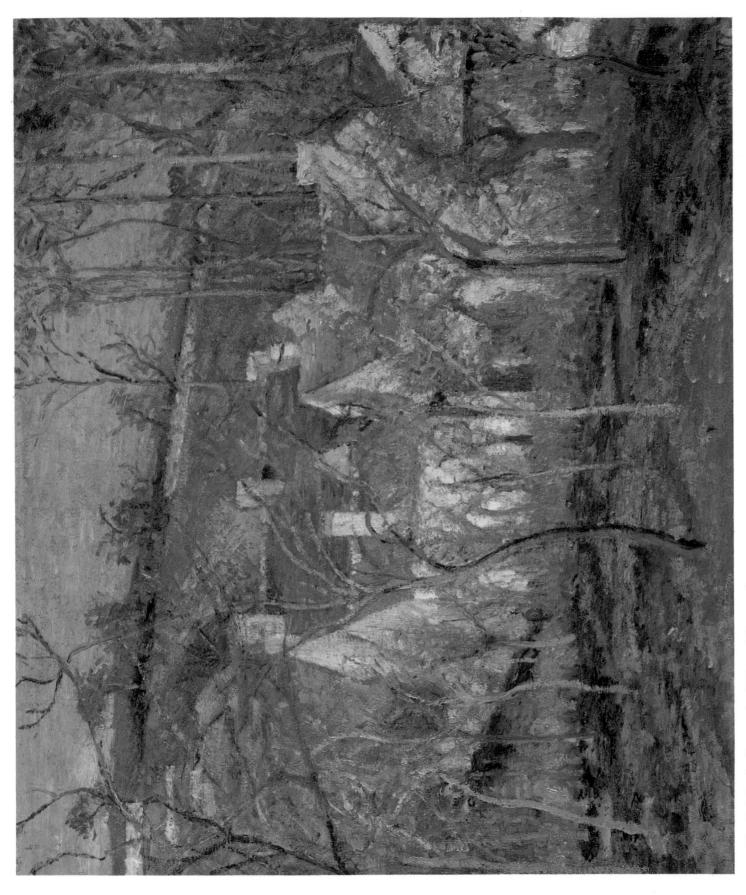

20. *The Red Roofs, Corner of a Village, Winter.* 1877.
Paris, Louvre (Jeu de Paume)

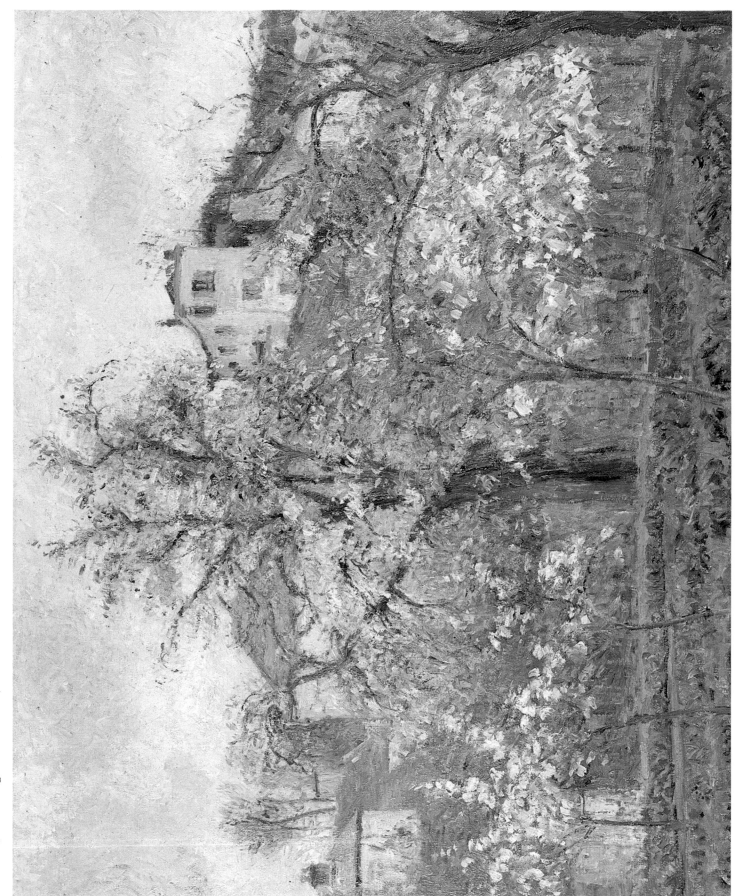

21. *Kitchen Garden with Trees in Flower, Spring, Pontoise.* 1877. Paris, Louvre (Jeu de Paume)

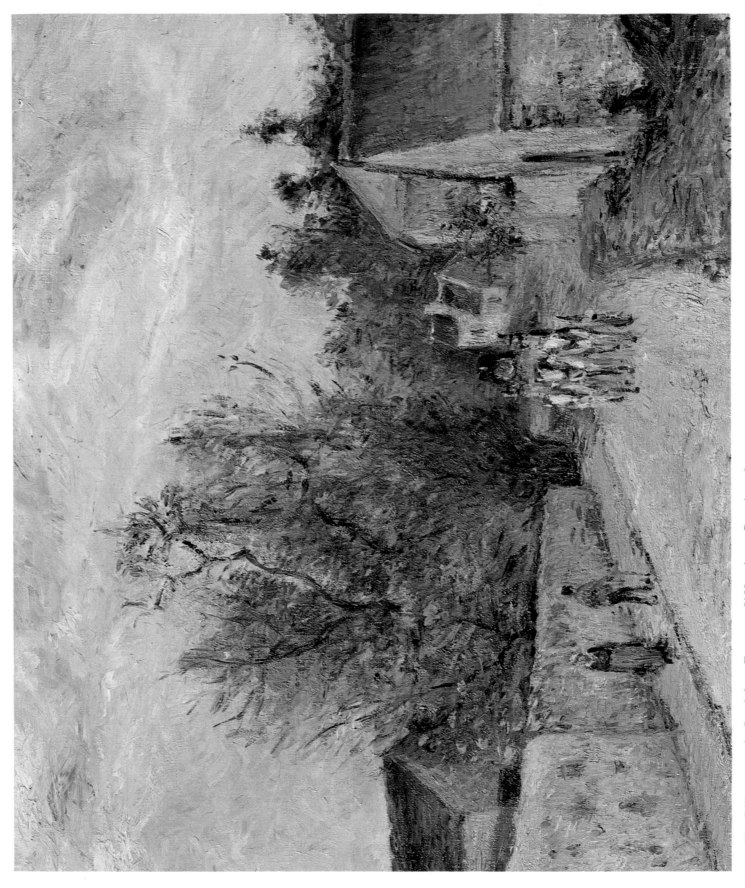

22. *The Diligence on the Road from Ennery to L'Hermitage, Pontoise.* 1877. Paris, Louvre (Jeu de Paume)

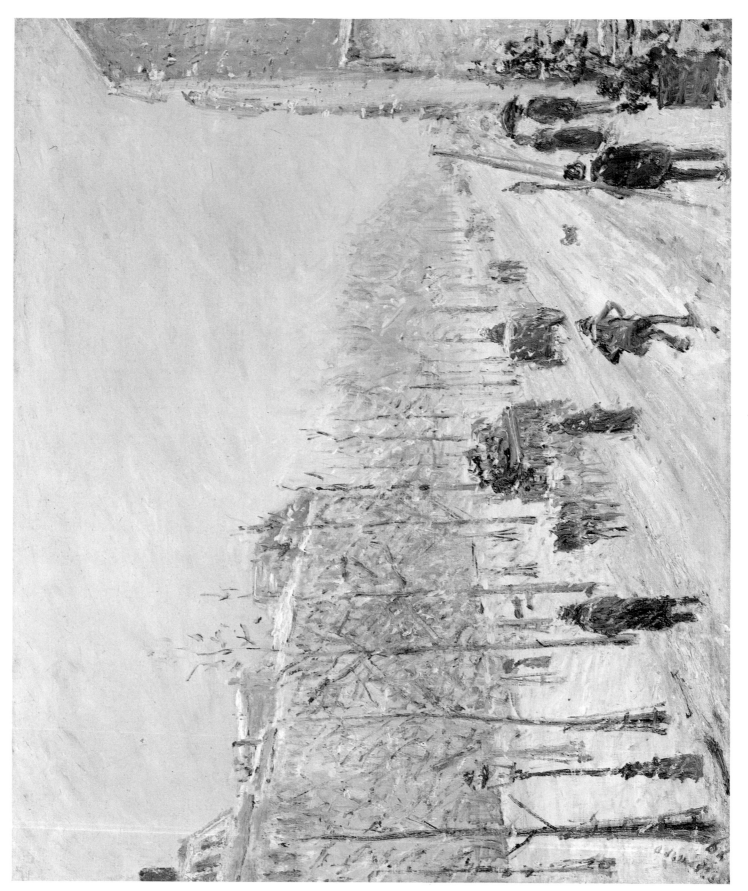

23. *The Boulevards, Snow.* 1879.
Paris, Musée Marmottan

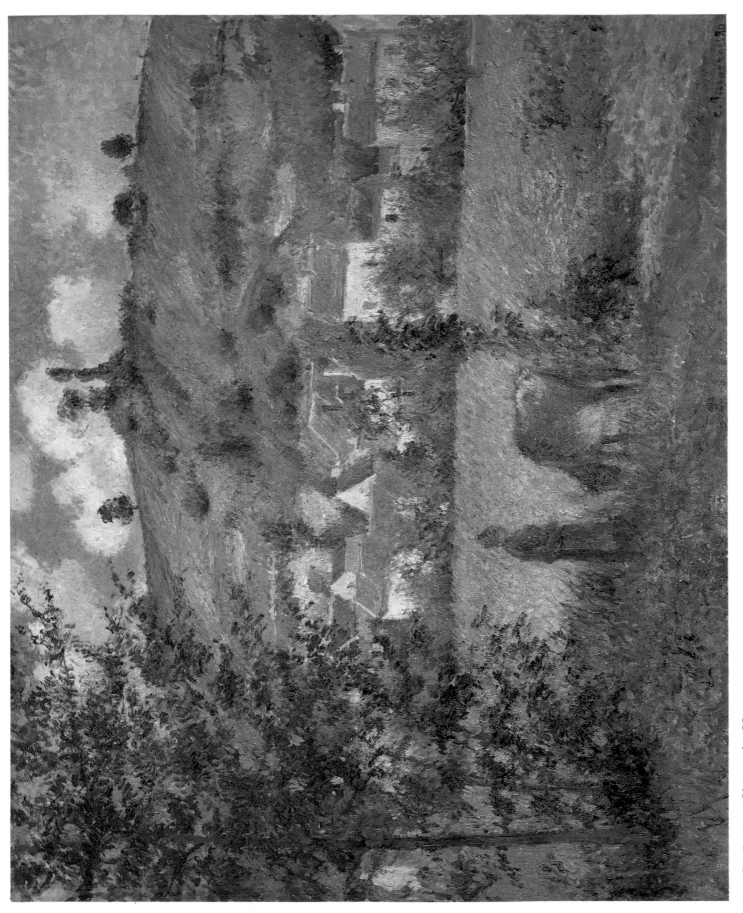

24. *Landscape at Chaponval. 1880.*
Paris, Louvre (Jeu de Paume)

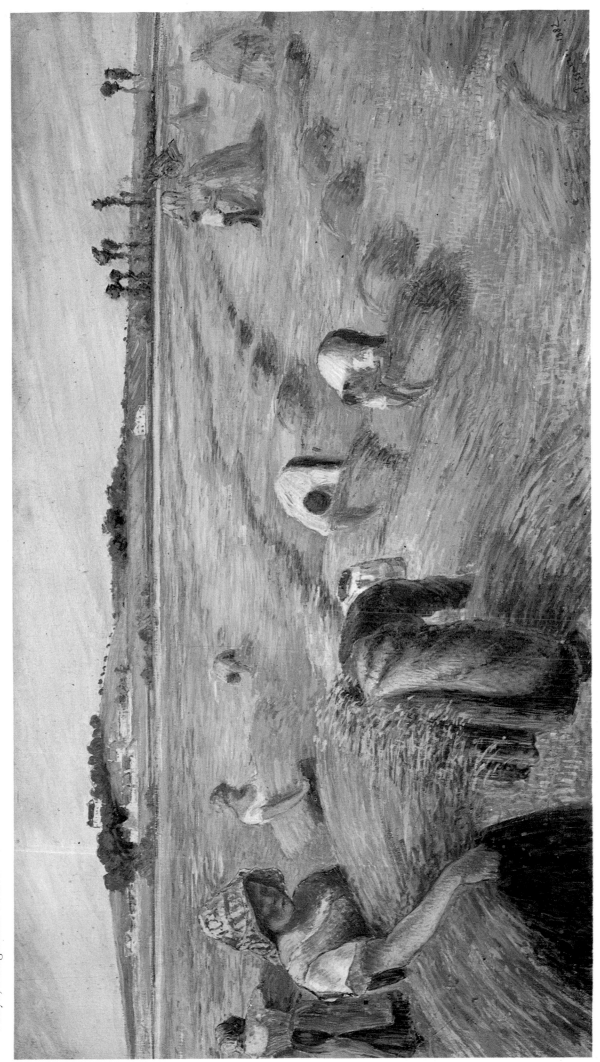

25. *The Harvest.* 1882.
Tokyo, Bridgestone Museum of Art

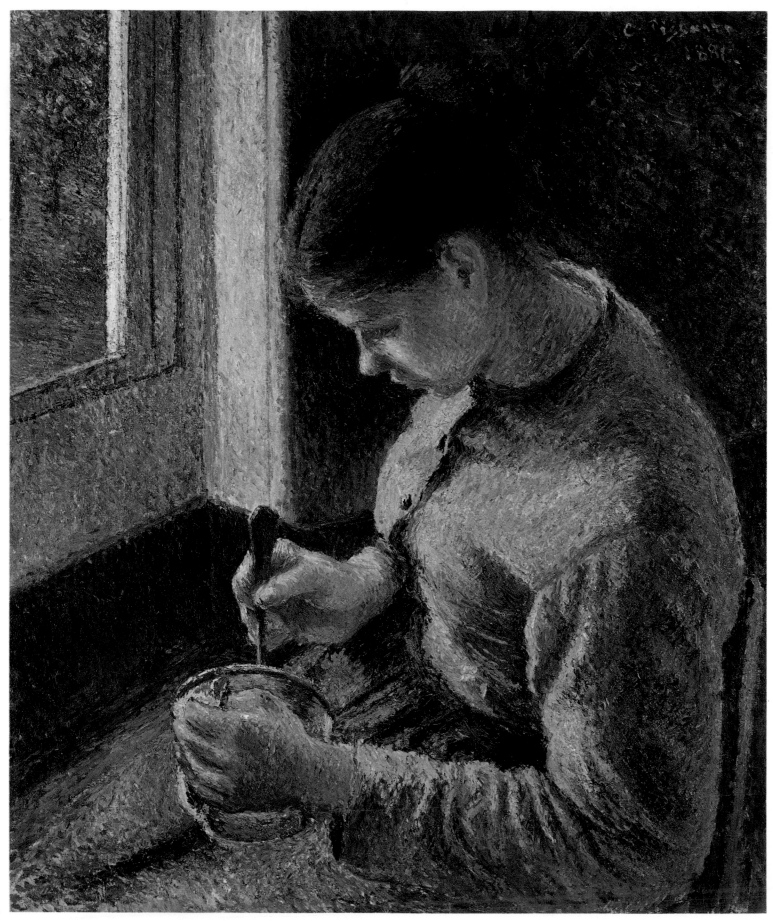

26. *Breakfast, Young Female Peasant Taking her Coffee.* 1881.
Chicago, Art Institute (Potter Palmer Collection)

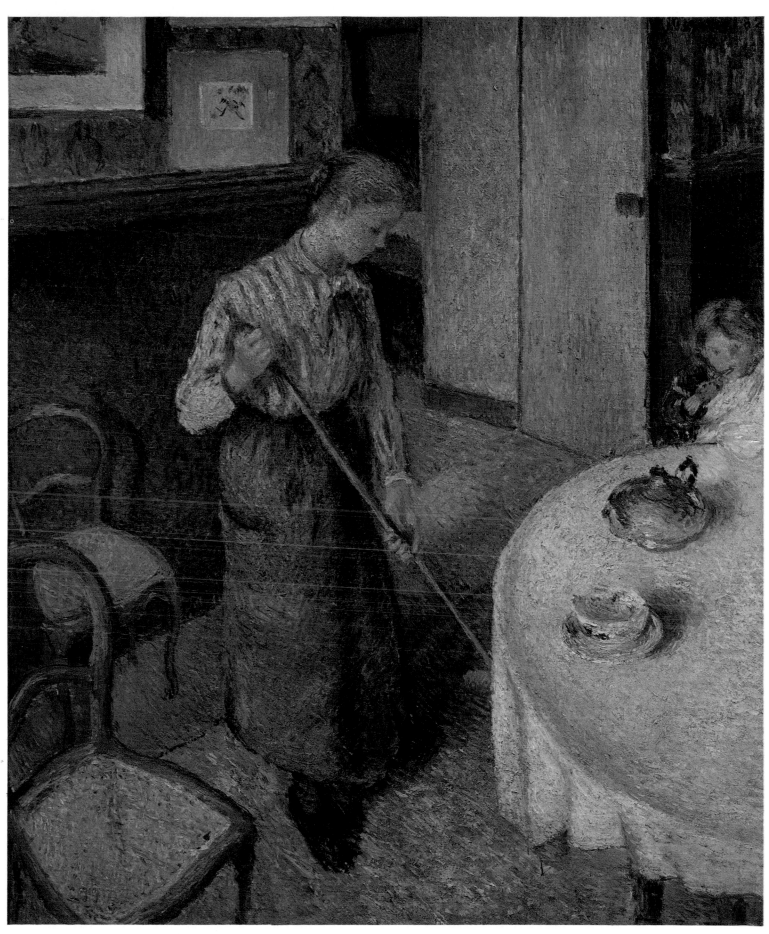

27. *The Little Country Maid*. 1882.
London, Tate Gallery (Pissarro Bequest)

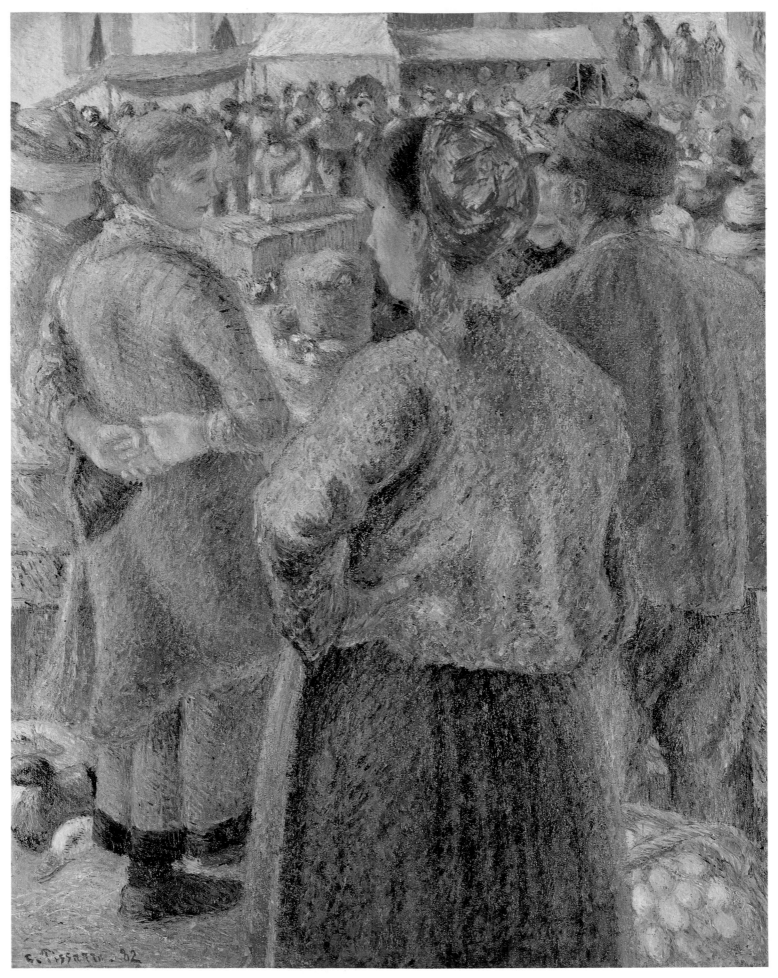

28. *The Poultry Market, Pontoise.* 1882.
Los Angeles, Norton Simon Foundation

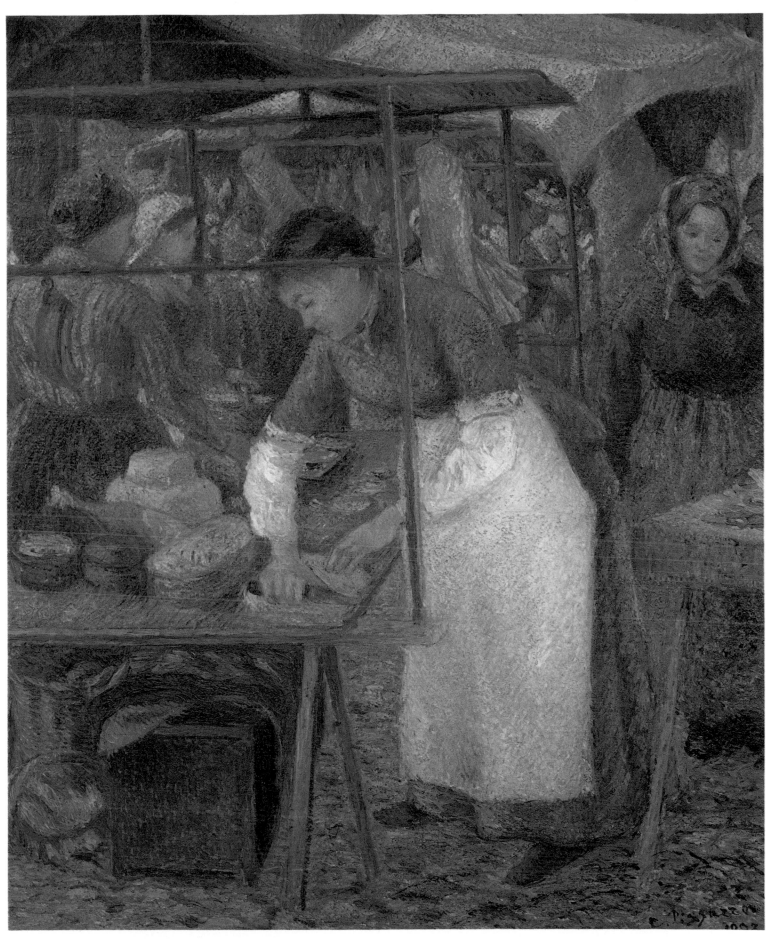

29. *The Pork Butcher*. 1883.
London, Tate Gallery (Pissarro Bequest)

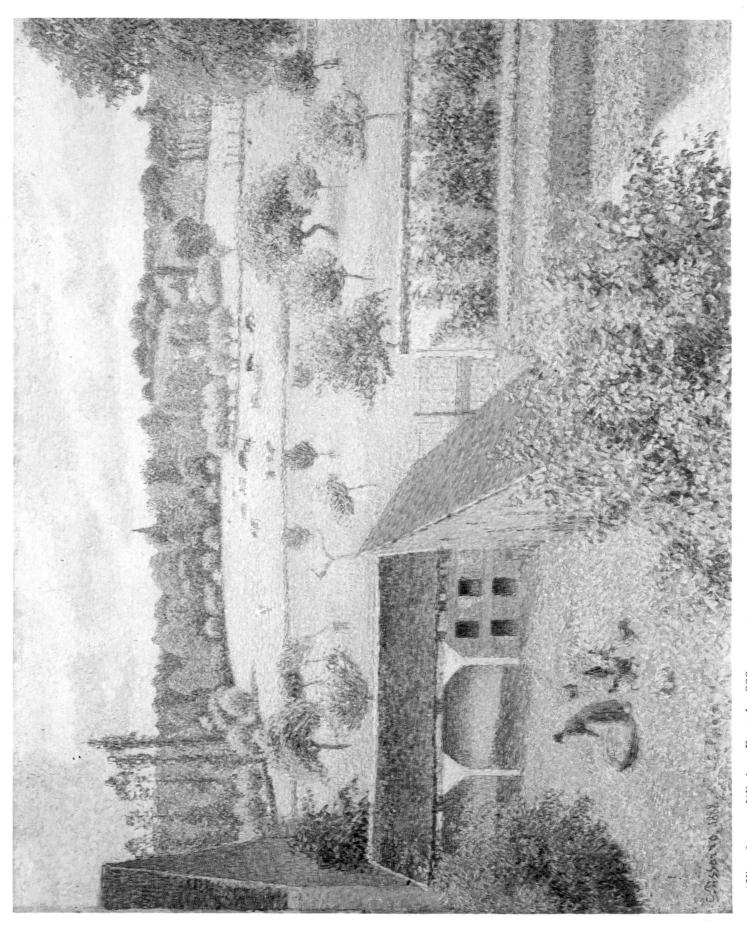

30. *'View from my Window, Eragny'*. 1888.
Oxford, Ashmolean Museum (Pissarro Gift)

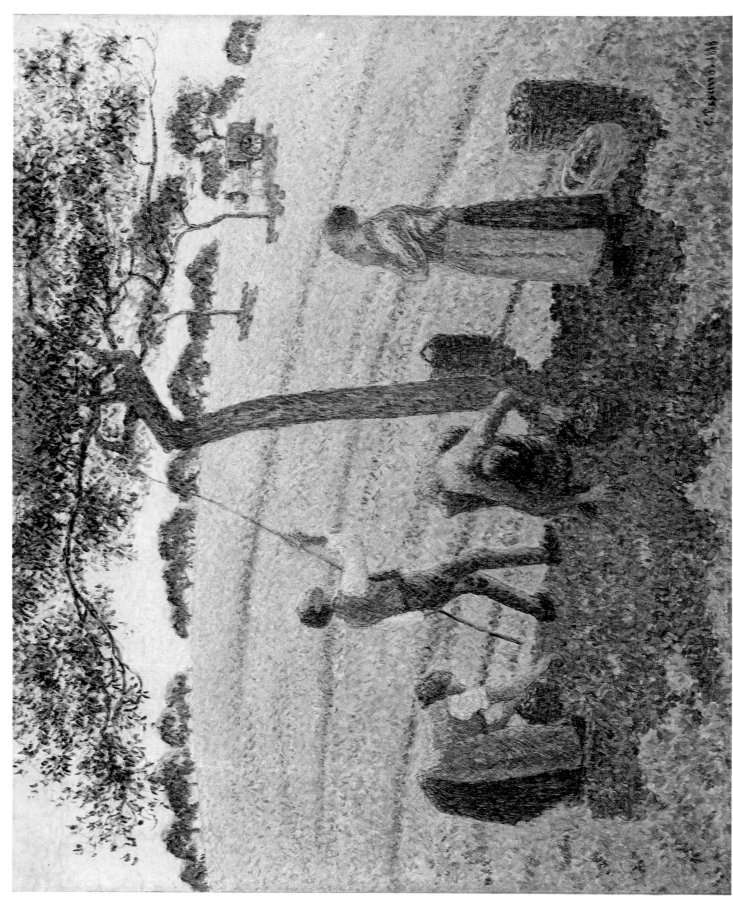

31. *The Apple Pickers, Eragny.* 1888.
Dallas, Museum of Fine Art

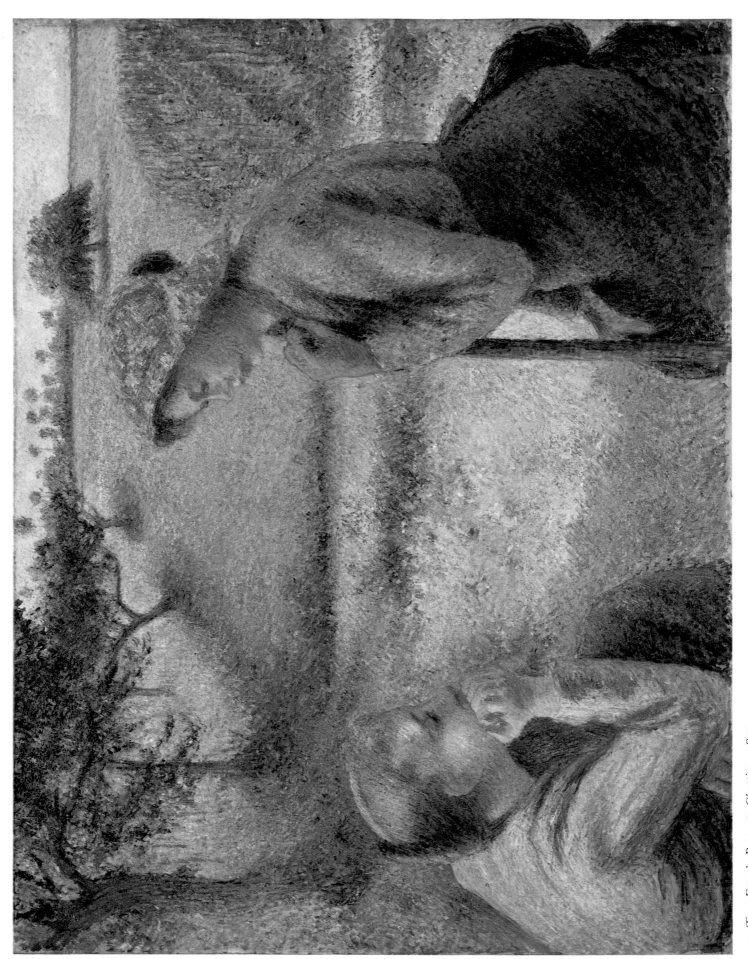

32. *Two Female Peasants Chatting.* 1892.
New York, Metropolitan Museum of Art (Wrightsman Collection)

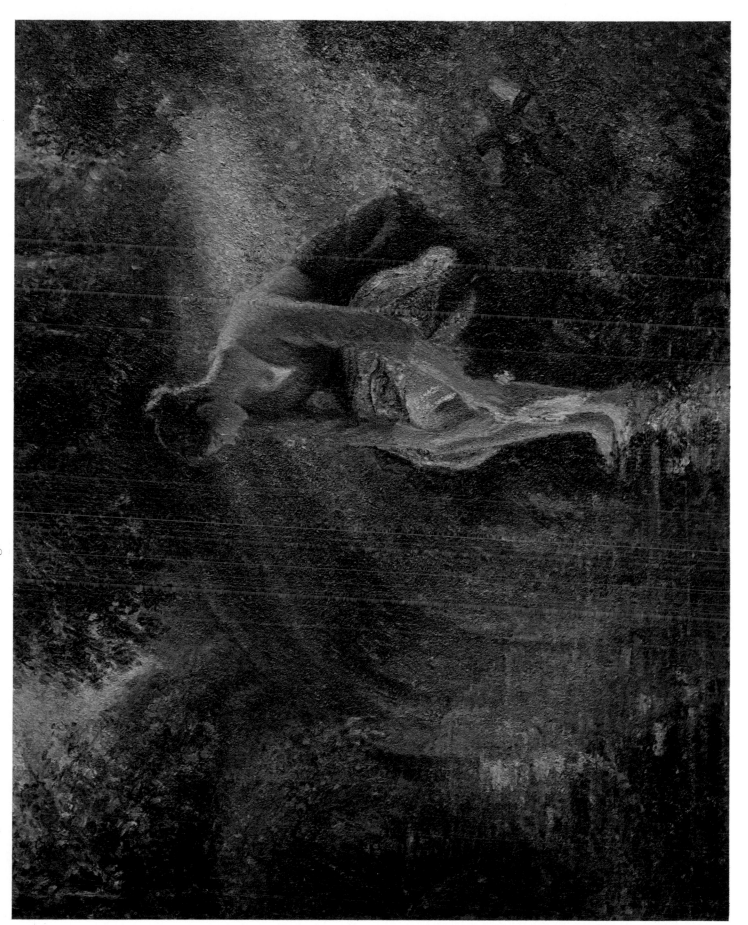

33. *Peasant Girl Bathing her Legs.* 1895.
New York, Collection of Mr and Mrs Nathan Cummings

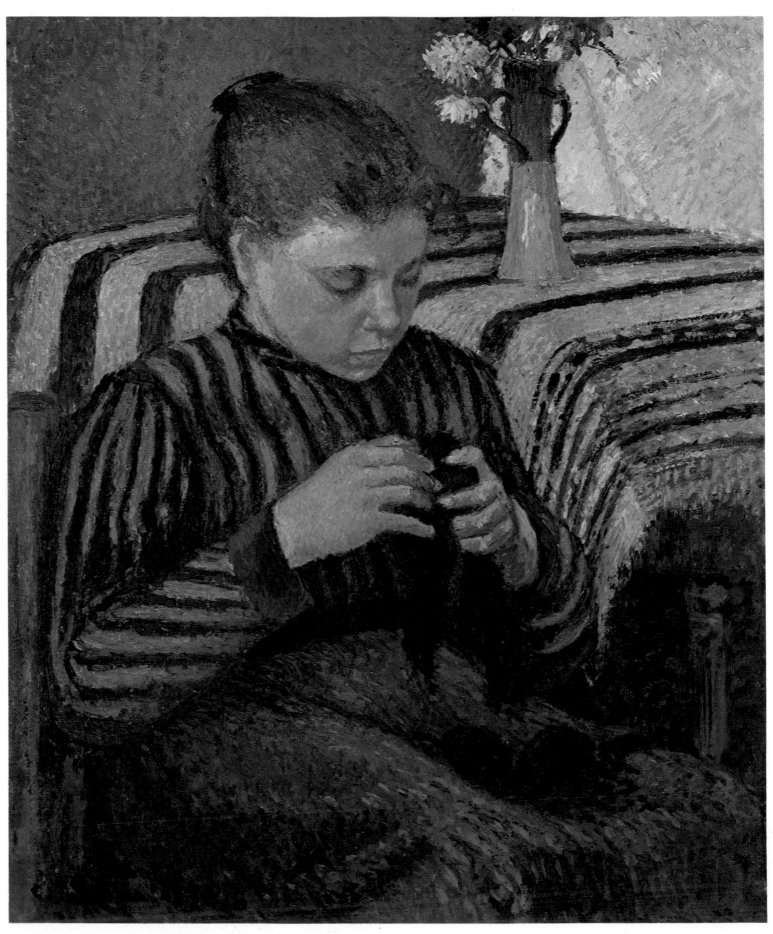

34. *Young Girl Mending her Stockings.* 1895.
Chicago, Art Institute (Leigh B. Block Collection)

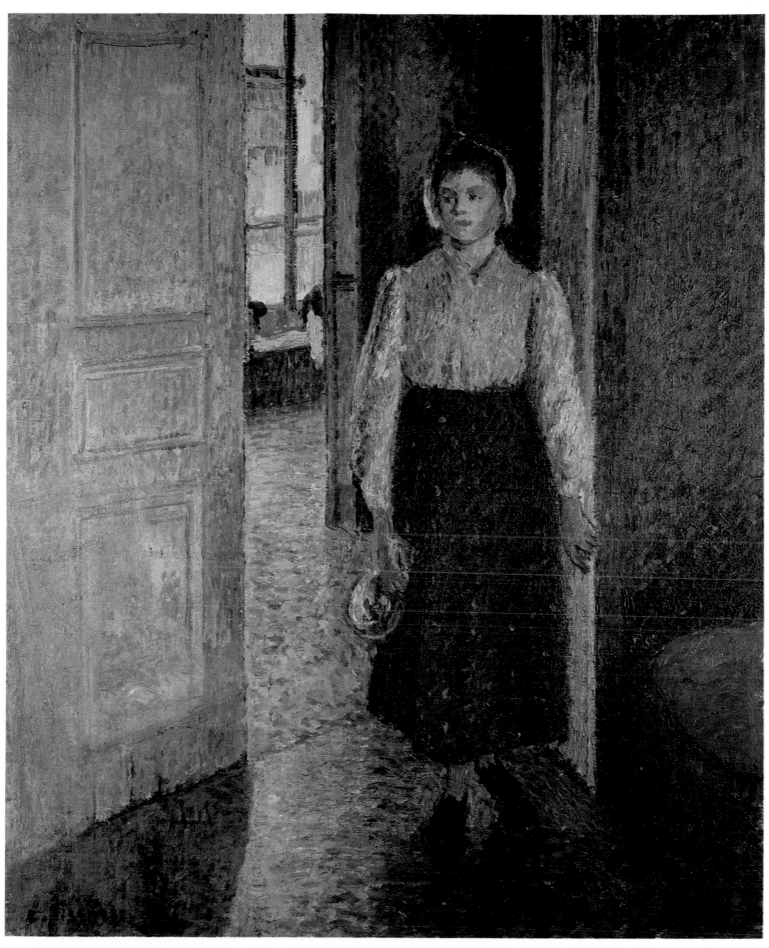

35. *The Young Maid.* 1896.
Manchester, Whitworth Art Gallery, on loan from a private collection

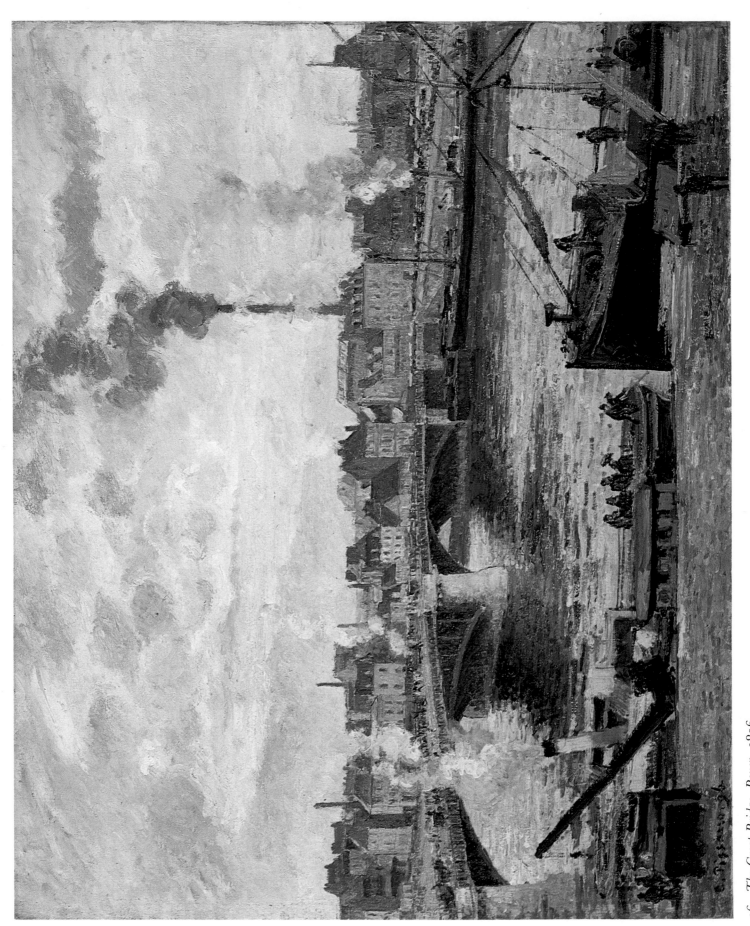

36. *The Great Bridge, Rouen.* 1896.
Pittsburgh, Museum of Art, Carnegie Institute

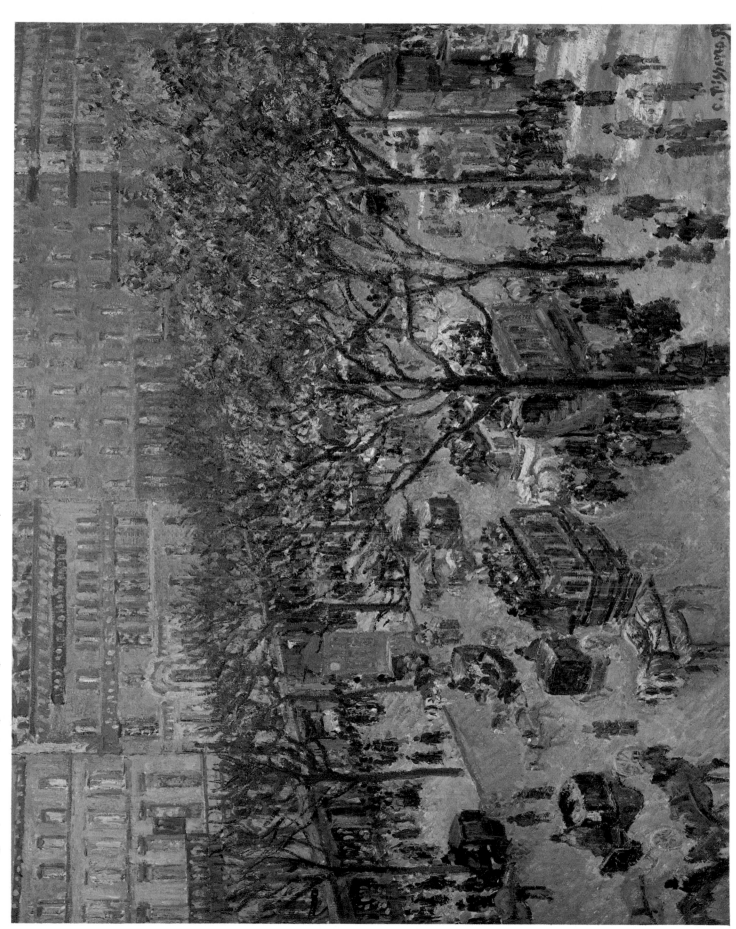

37. *Boulevard des Italiens, Paris, Morning, Sunlight.* 1897.
Washington, National Gallery of Art (Chester Dale Collection)

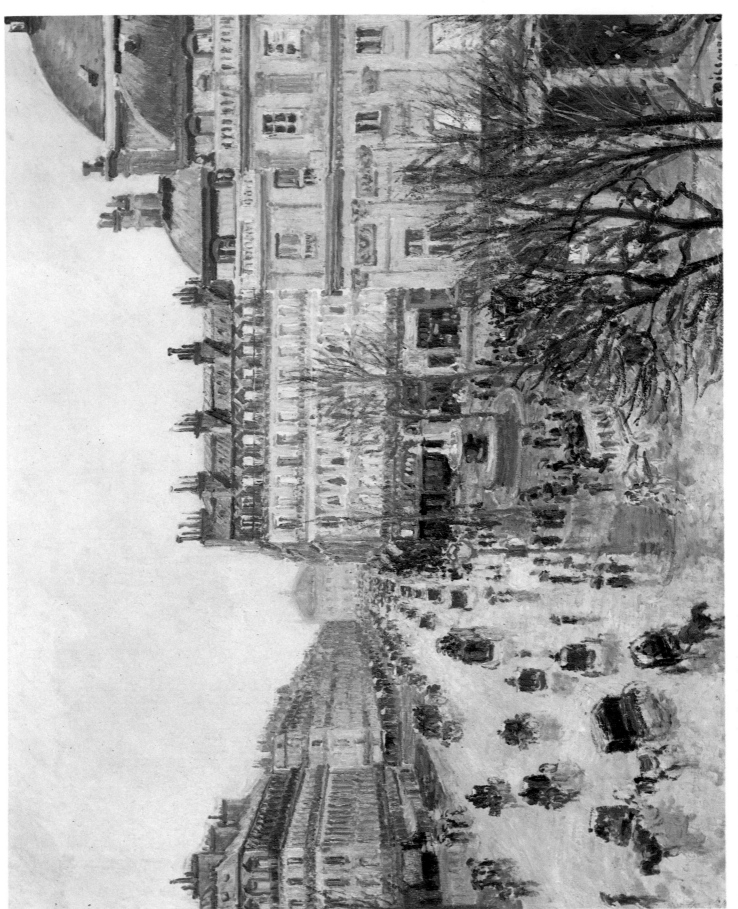

38. *La Place du Théâtre Français, Paris, Rain.* 1898.
Minneapolis, Institute of Fine Arts

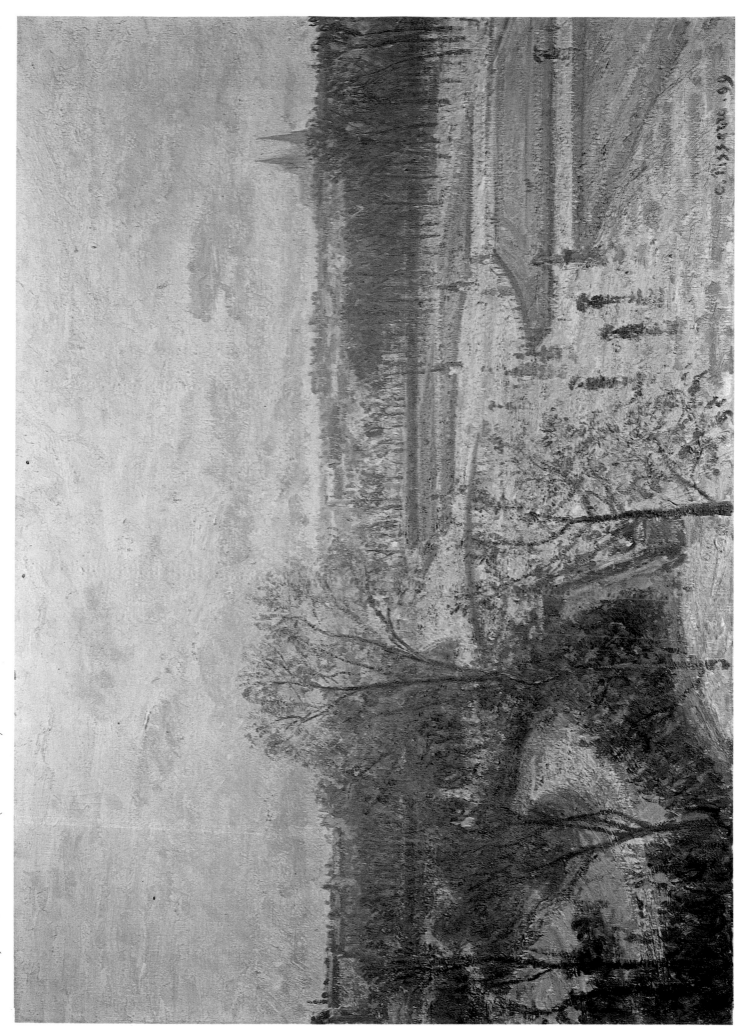

39. *The Tuileries Gardens, Paris, Rain.* 1899.
Oxford, Ashmolean Museum (Pissarro Gift)

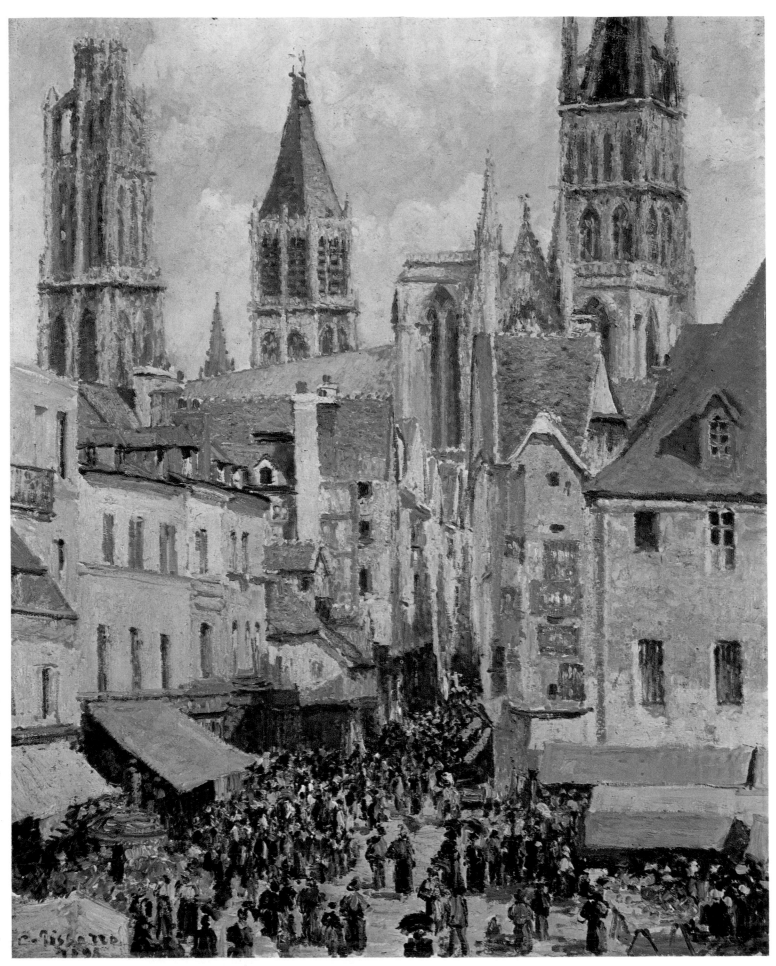

40. *The Old Market and the Rue de l'Epicerie, Rouen, Morning, Grey Weather.* 1898.
New York, Metropolitan Museum of Art (Mr and Mrs Richard J. Bernhard Fund)

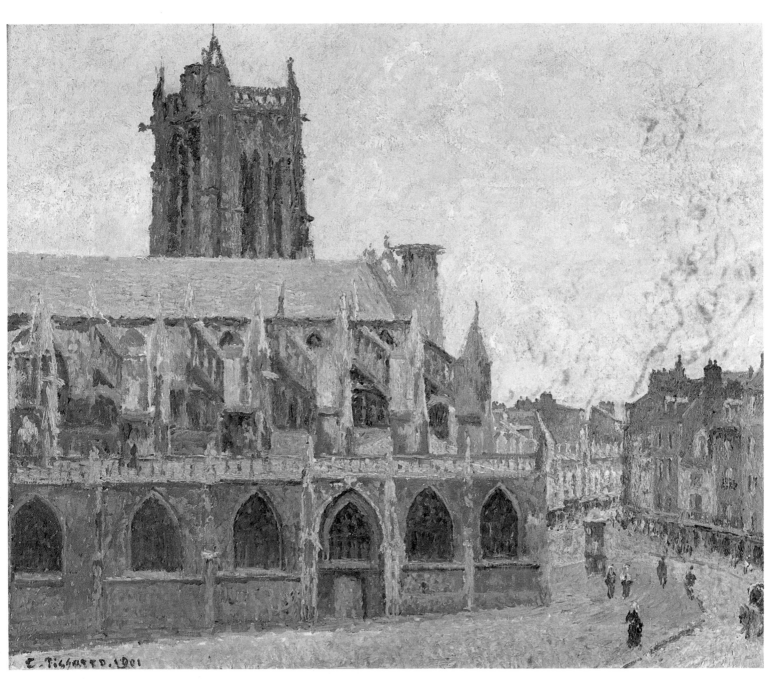

41. *The Church of St Jacques, Dieppe.* 1901.
Paris, Louvre (Jeu de Paume)

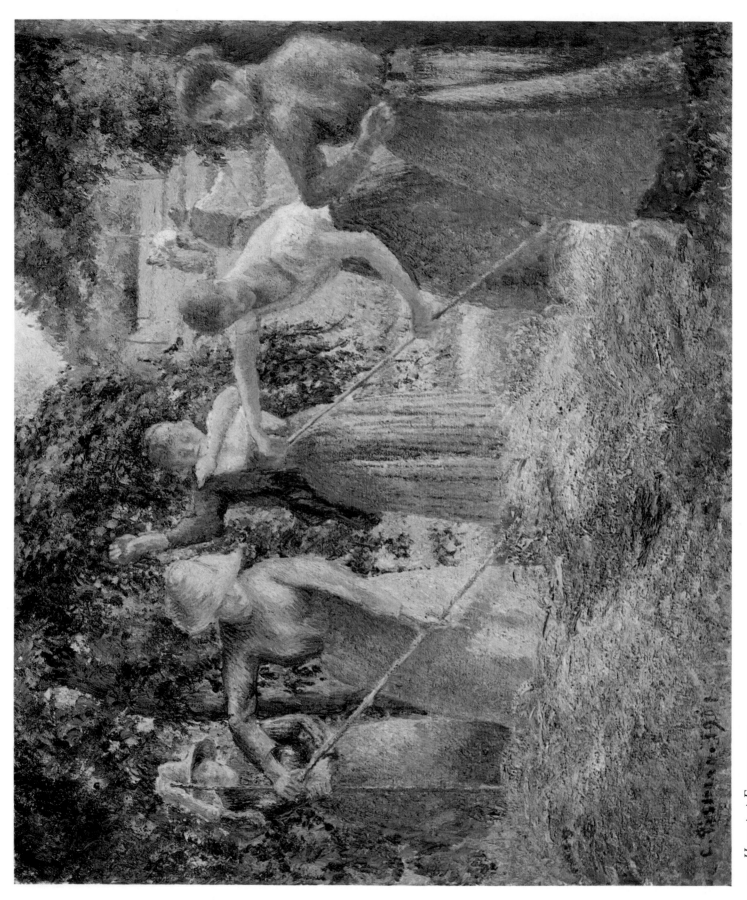

42. *Harvest at Eragny.* 1901.
Ottawa, National Gallery of Canada

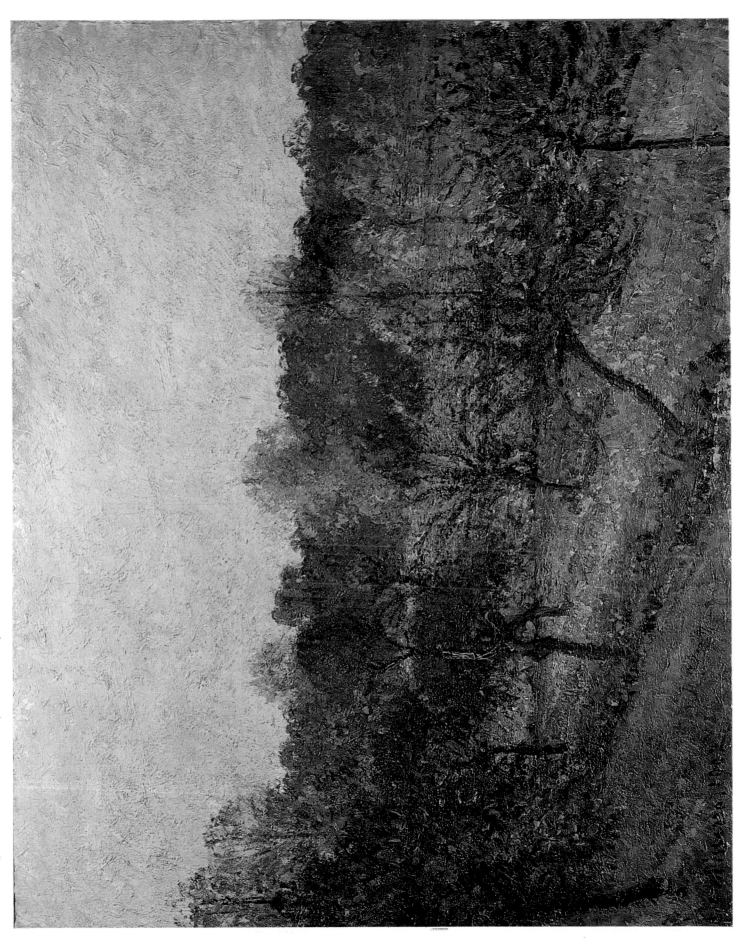

43. *Sunset at Eragny, Autumn.* 1902.
Oxford, Ashmolean Museum (Pissarro Gift)

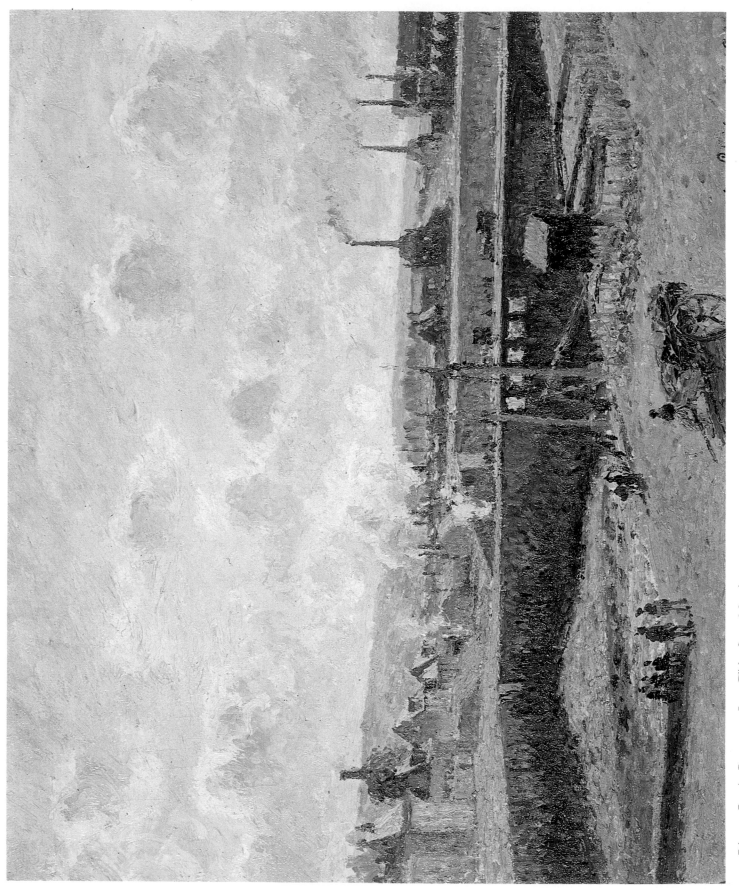

44. *Dieppe, Bassin Duquesne, Low Tide, Sun, Morning.* 1902.
Paris, Louvre (Jeu de Paume)

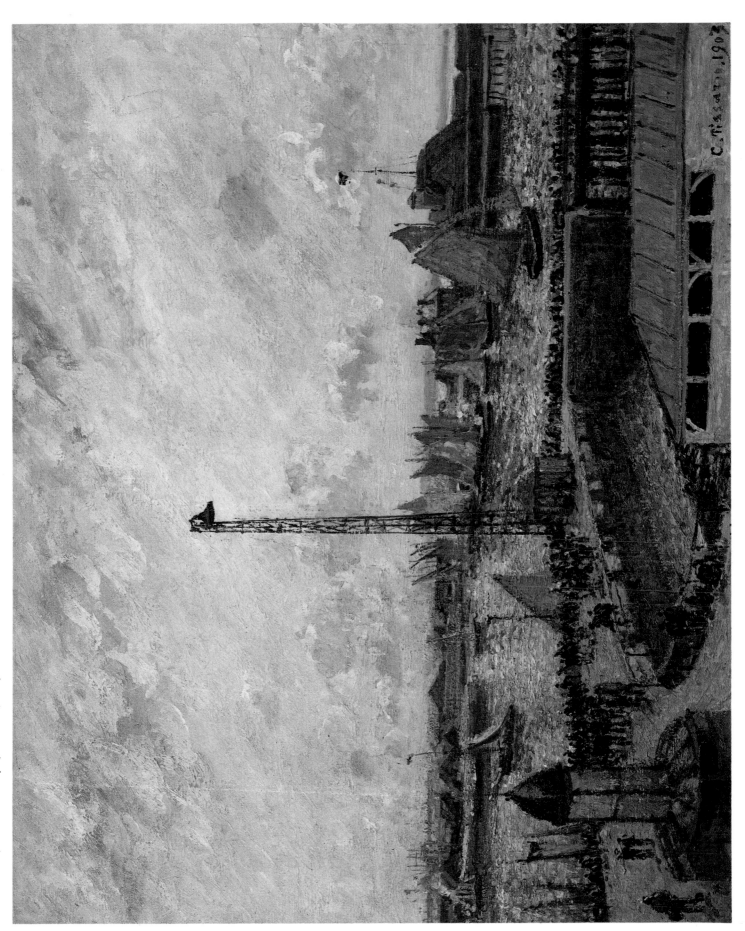

45. *The Pilot's Jetty, Le Havre, Morning,Grey Weather, Misy.* 1903. London, Tate Gallery (Pissarro Gift)

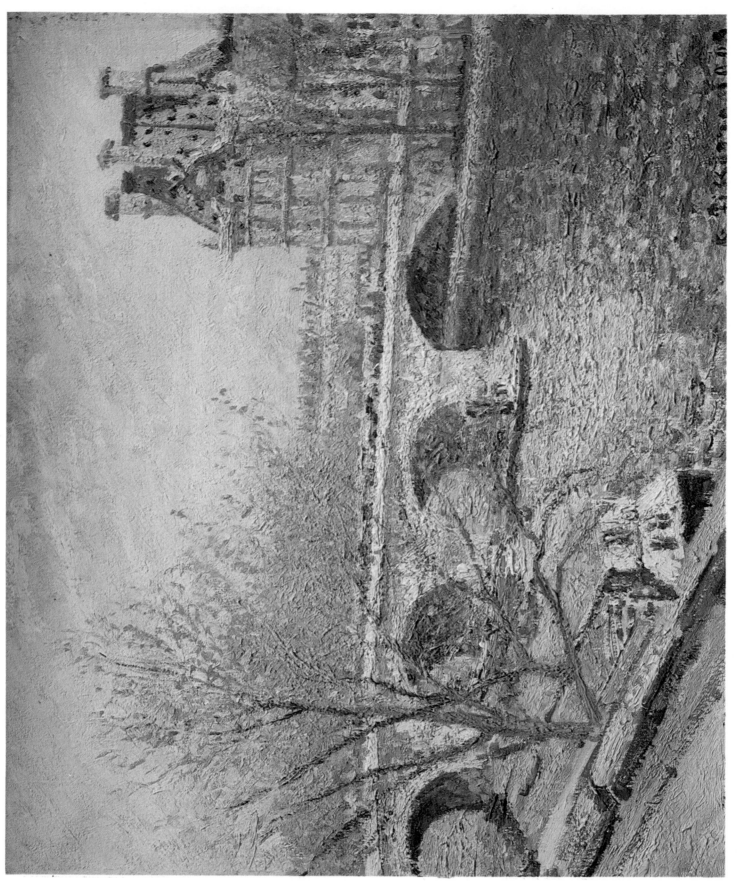

46. *Pont Royal and the Pavillon de Flore, Paris.* 1903.
Paris, Musée du Petit Palais

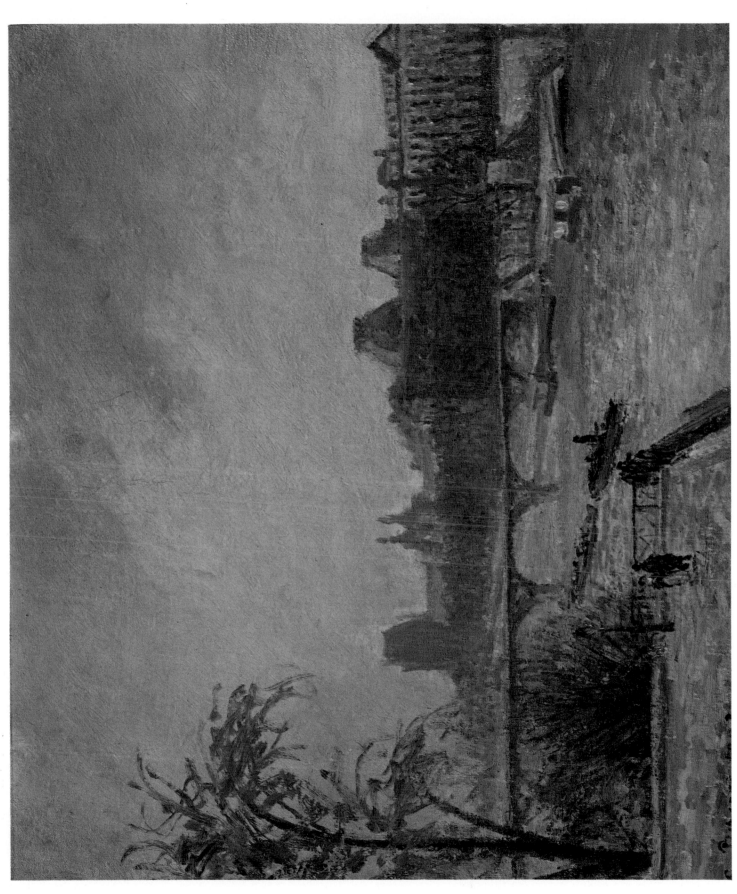

47. *The Seine and the Louvre, Paris.* 1903.
Paris, Louvre (Jeu de Paume)

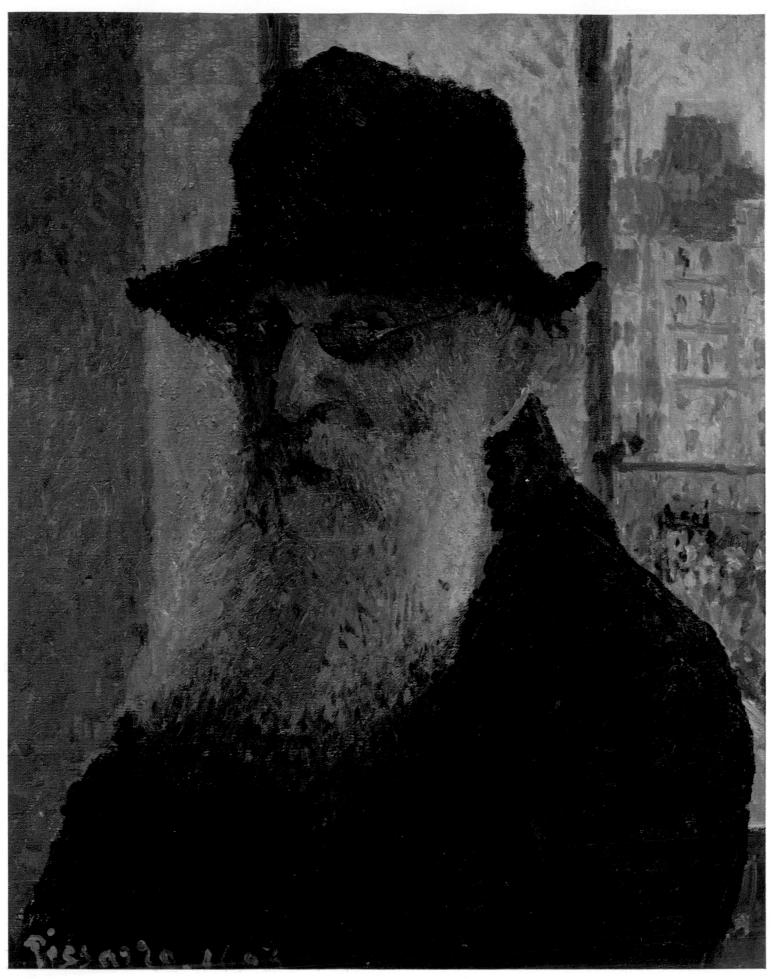

48. *Self-Portrait.* 1903.
London, Tate Gallery (Pissarro Gift)